NOBLE.
DIGNIFIED.
BEAUTIFUL.

The Quiet Elegance of the Horse

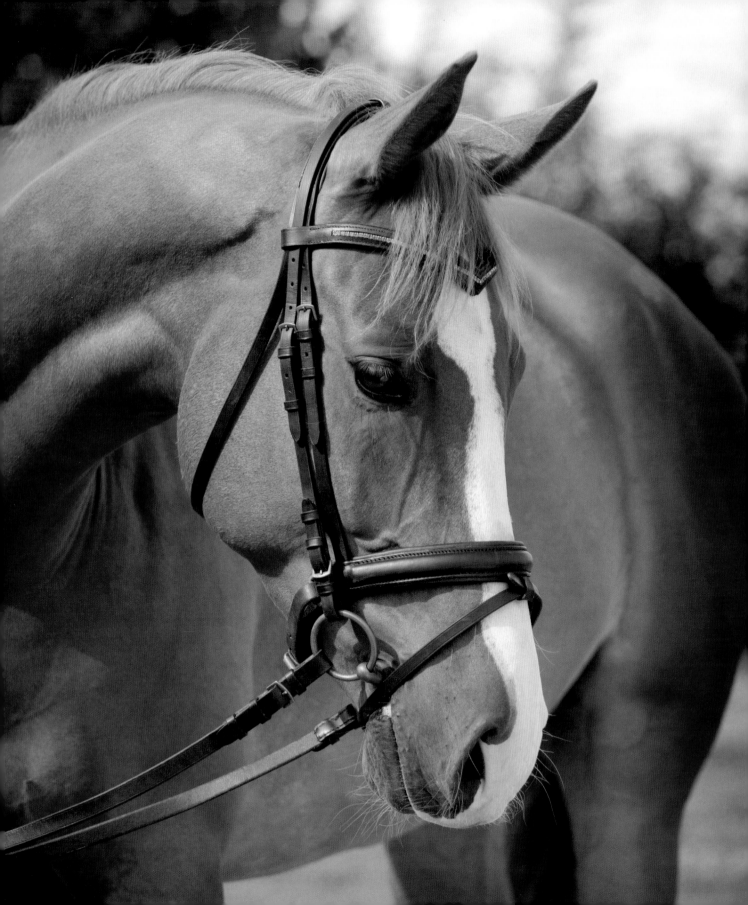

NOBLE. DIGNIFIED. BEAUTIFUL.

The essence of the horse must have as many faces as there are people who admire it. Those to whom horses are an endearment in their lives see something distinct in the gaze of a horse, and its appearance means something different to them than to the next person.

Each day my own horses and all those I meet during my travels throughout the country make me aware of the richness of life – and that this wealth kneels at our feet, that it lies all around us. In the horses it beckons for our touch. It is a treasure belonging to all of us: it is the beauty that ennobles all of our lives with its dignity.

My love for horses is a song in my heart, and my pictures sing my gratitude for them. They express my joy, my passion, my will, and my dreams. And in every horse I meet I see the light which I follow on light feet.

This book is for Lars, for Isabelle and for Divinitas. And for all those who love horses. May every one of you see in the horses that which always fascinates myself more than their strength and energy – the gentleness, and most of all, the noble aura that surrounds them:

THE QUIET ELEGANCE OF THE HORSE

DISTANT
GAZE

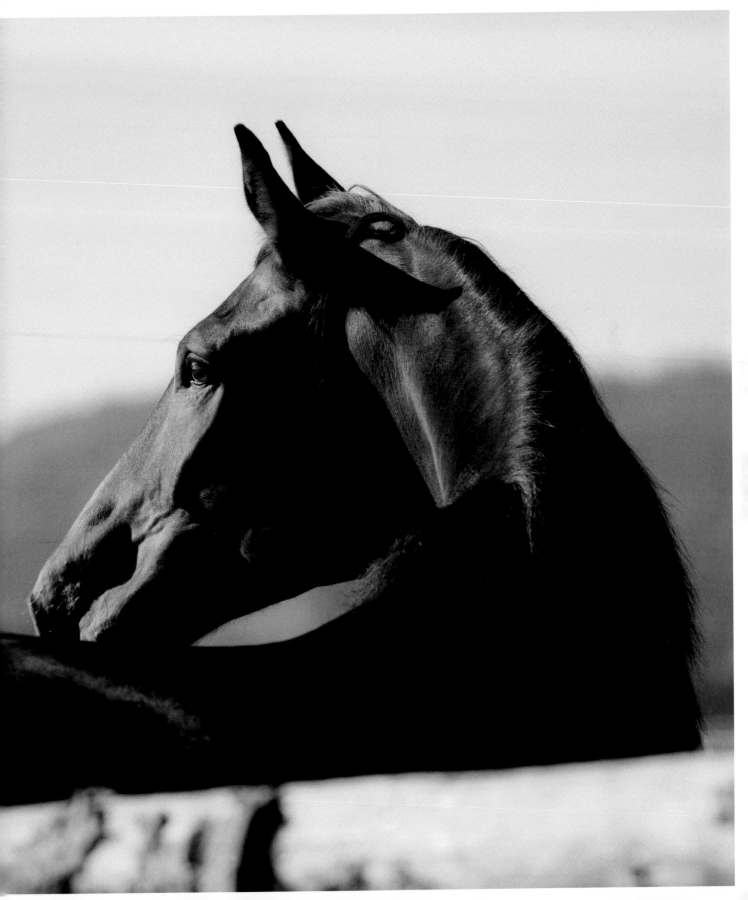

Between summer and winter, between sun and rain, lie differences as vast as the skies. But as different the rhythm, so alike the melody: day in, day out, the love for horses sounds in our lives. Be it whistling or singing – it is a song without end. It is cheerful in summer, and it may be restrained a little in winter, but it can always be heard.

Pictures are music to me. One cannot be separated from the other. And I listen closely: to the sound of the breath of a horse, to its call, to its contented chewing. I look into its eyes, and then I hear its verse of our song: it sings of distant ranges, of freshness — and of the joy of beautiful summer morns.

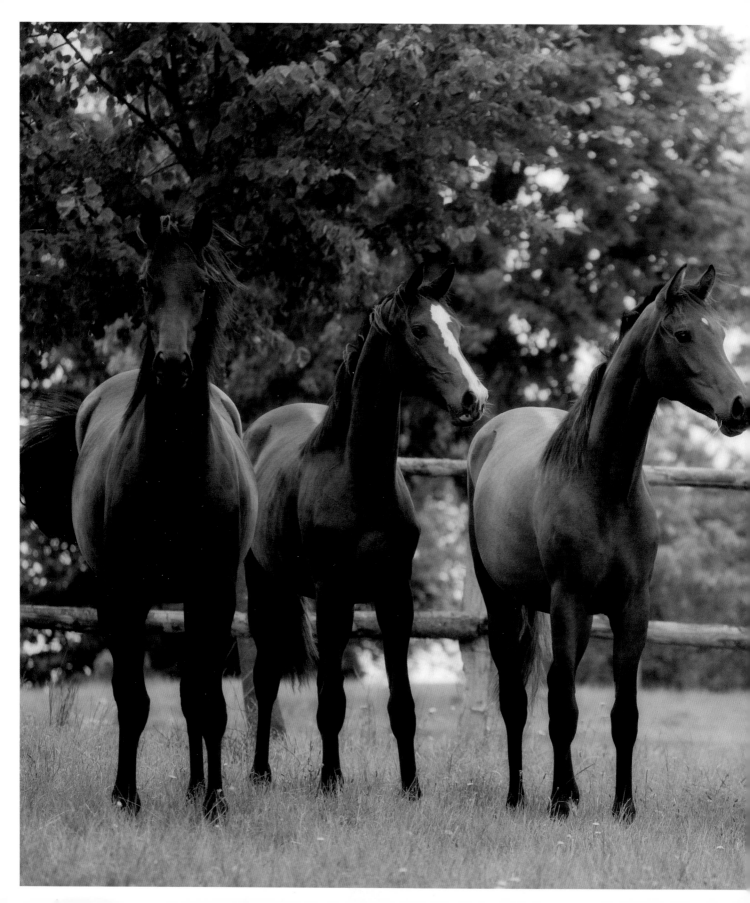

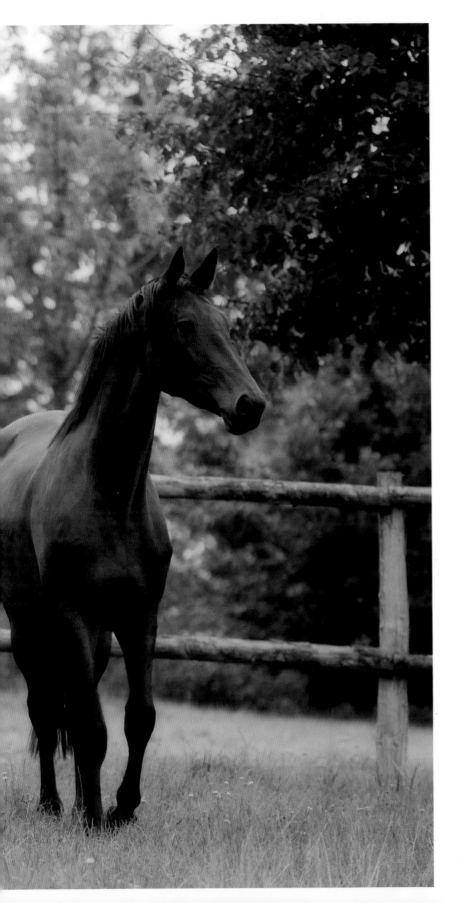

COURT
ENTOURAGE

Delicacy, elegance, charm. And curiosity.
In a group of young mares these qualities
are abundant.

Usually, such small herds attract less attention
than groups of young stallions, but spending
time among mares can be a very special
experience.

They relate differently, their notions seem
more finely nuanced. So fine, in fact, that
they may flee superficial observation. Mares
may be less spectacular in their actions than
stallions, but I feel them to be much more
committed in their bonding.

Some make no secret of it.
Surely not Infanta.

11

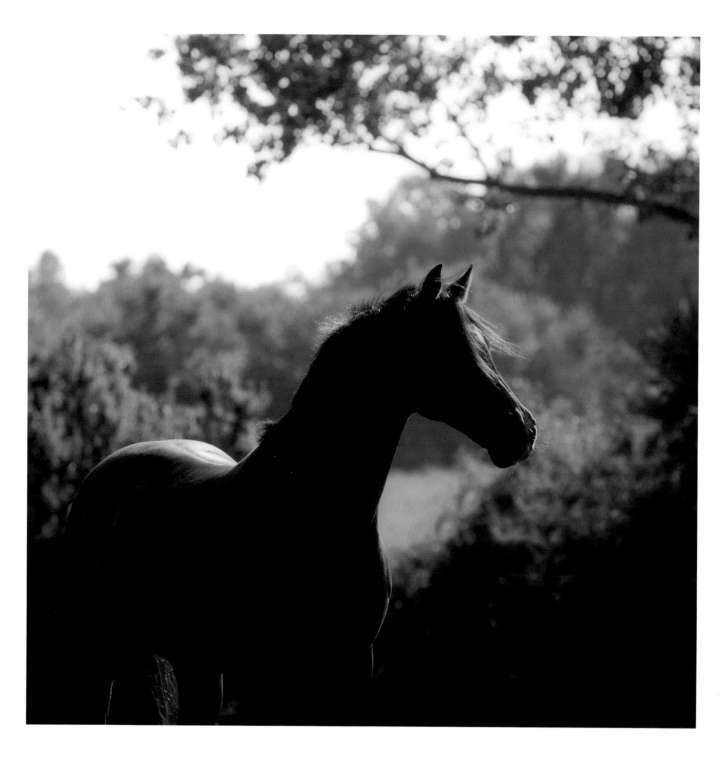

Every horse is inhabited by beauty.

One may delight in sharing it from a distance, another makes a gift of it close up.

But none can deny it.

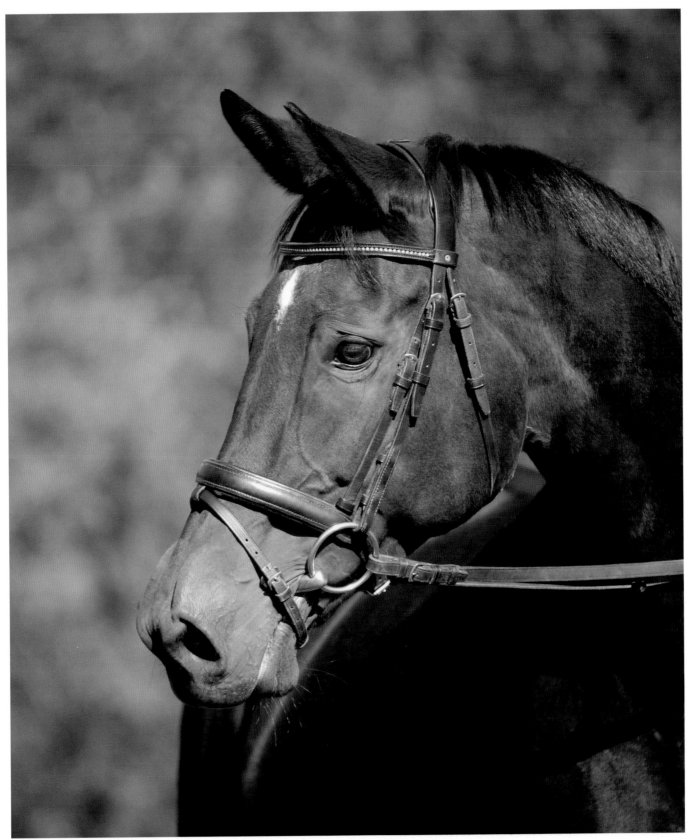

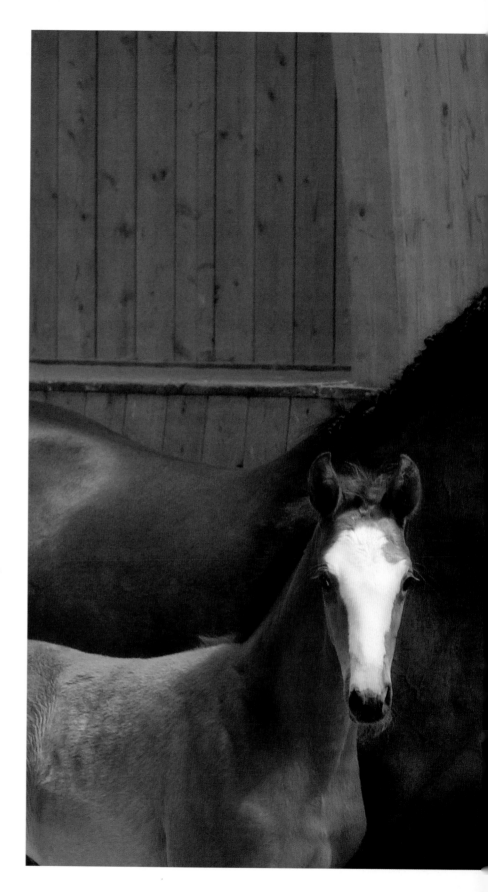

MOTHER
DAUGHTER
FAMILY
FRIENDS

An old German truth says: "To breed horses is to think in generations."

In breeding horses the present, the past and the future blend into one, as hopes for the future and memories of the past meet in the care of the present.

Foal registrations and shows count among the highlights in the life of a breeder and within just a few moments all the considerations of many years come to matter.

Everyone involved has their eyes set on their prospects.

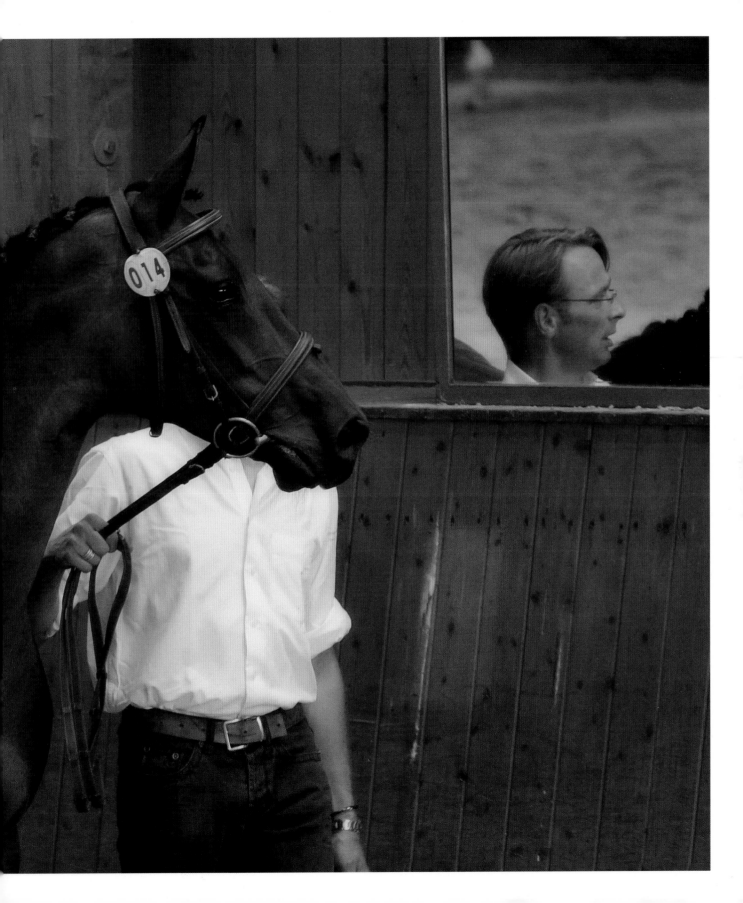

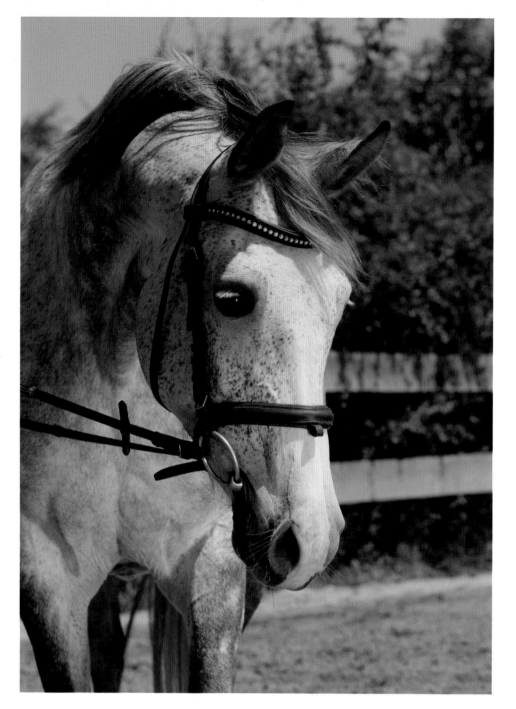

A picture tells more than a thousand words.

Ten thousand?
One hundred thousand!

And for this to be so not much has to happen in a picture. Quite the contrary.

With a mere glance a horse can express all its dignity and warmth – its ability to soothe us with its nearness or to lend us strength.

Be it the tender loving gaze of a mare or the interested look of a stallion. The blink of an eye can hold all of our world.

Nothing much has to happen in a picture.

For – more than simply seeing – the image of a horse can make us feel.

IN A
GLANCE
LIES THE WORLD

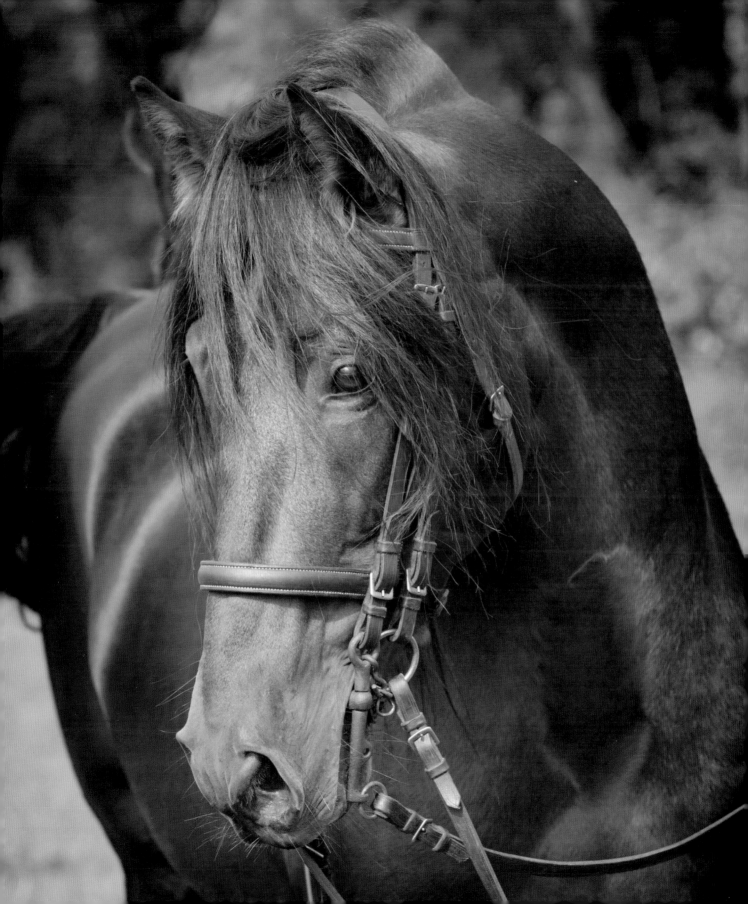

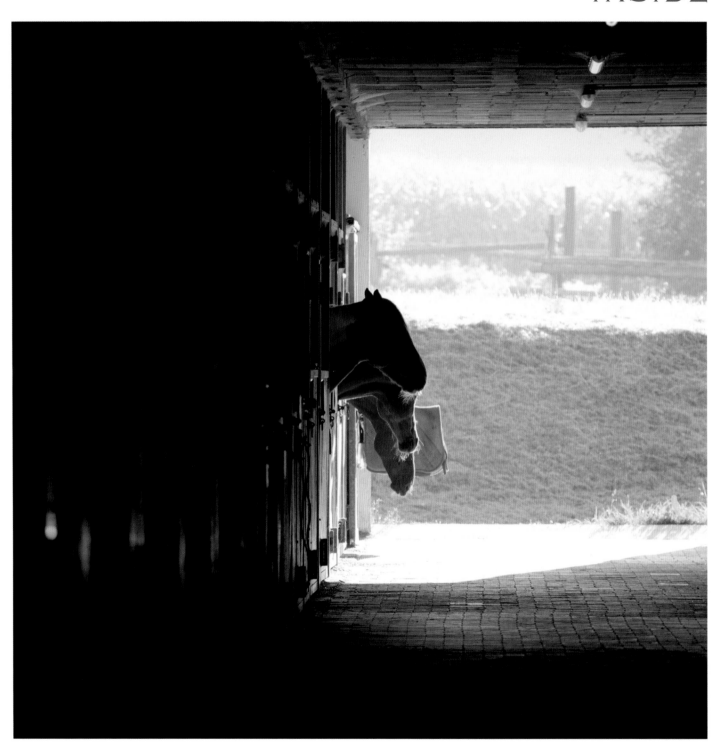

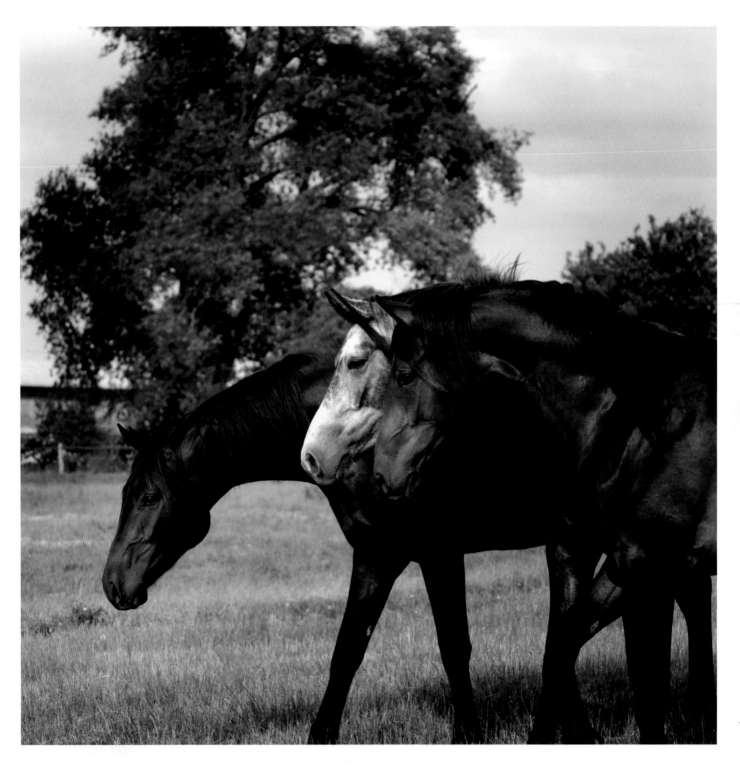

OUT

UNQUESTIONABLY
ILLUSTRIOUS

Many expectations are invested in stallions.

Some are predestined to have great careers, some spend their days far away from the noise of the glamorous breeding shows. Loved, tenderly cared for and highly esteemed, they father very special children.

Man has created some part of the beauty of the horse, and the vogue of times puts it centre-stage, but its nobility is given by nature and only the dignity of its essence makes it shine.

Some hand of man is able to grasp this and to preserve it in the children of such fathers.

Hamit lives on an isle in the Baltic Sea and leaves prominent hoofprints in the lives of those whose paths cross his.

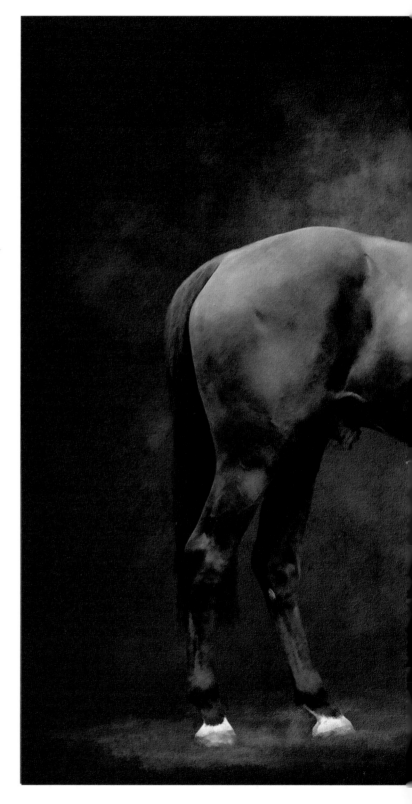

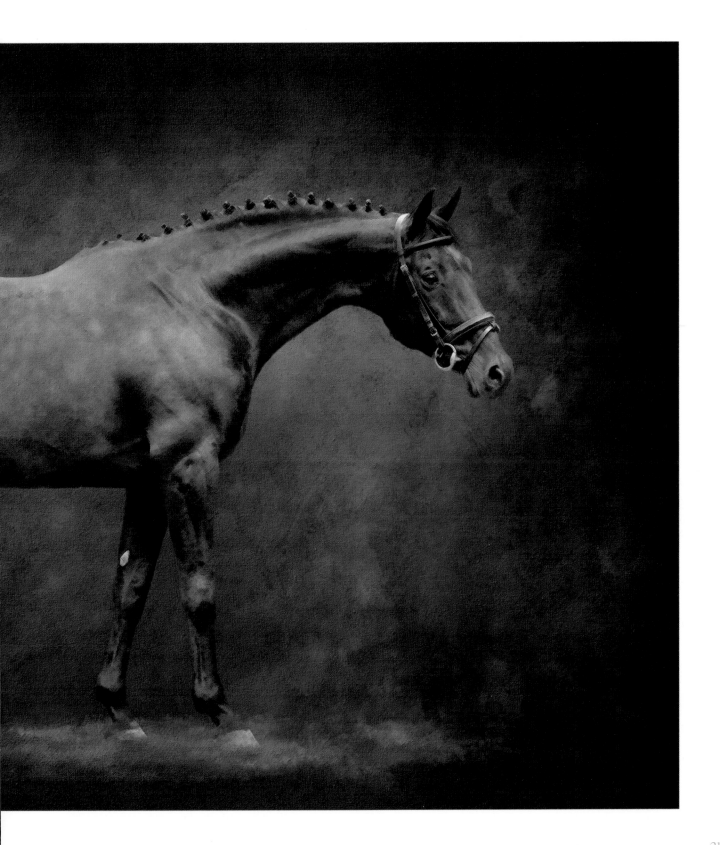

ONWARD
UPWARD
UP!

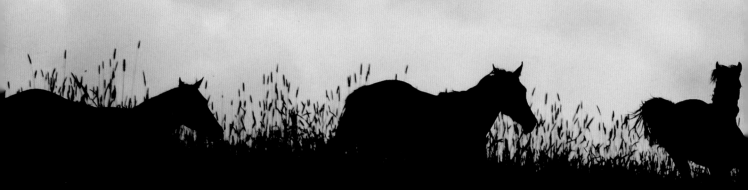

There are so many things we can learn from horses. And even when they aren't doing it consciously, but simply because it is their nature, because it is in their blood – in their actions they can be an example for us.

Wherever the will comes from, and however unwelcome its impetus may be for us, when a horse wants to go forward, it will. There is little that can keep it from doing so. Obstacles are jumped, run down or around. All doing follows only one impulse: "Forward!"

As a rule, we are different. We tend to think for longer. But that not only gives us a better overview, it also allows more room for doubt, and doubts weigh heavy. And with their weight they hinder our ability to move freely.

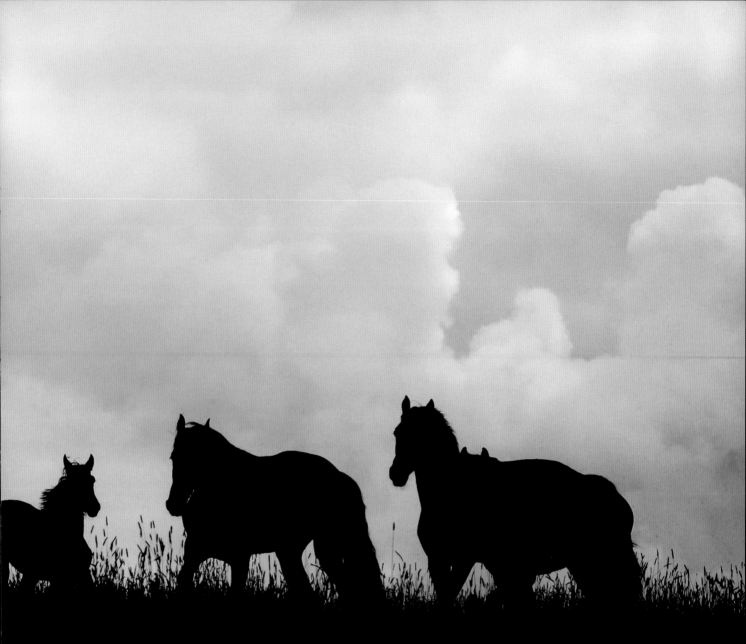

Not so with the horse. It subjects itself wholly to its motives. Be it getting away or getting where it wants to be, it arrives quickly at the conviction that it can achieve its goals by using all of its energy.

Horses are not stupid to begin with, but this devotion to just one impulse is a clever contrivance of nature – for being an animal of flight, the horse needs its confidence in its own strength to preserve its life.

To take horses for an example in some respects does not mean to be able to follow suit, but to have them with you in mind as you aim for the horizon can help you to win your next uphill battle.

Onward, as it is. Upward. Up!

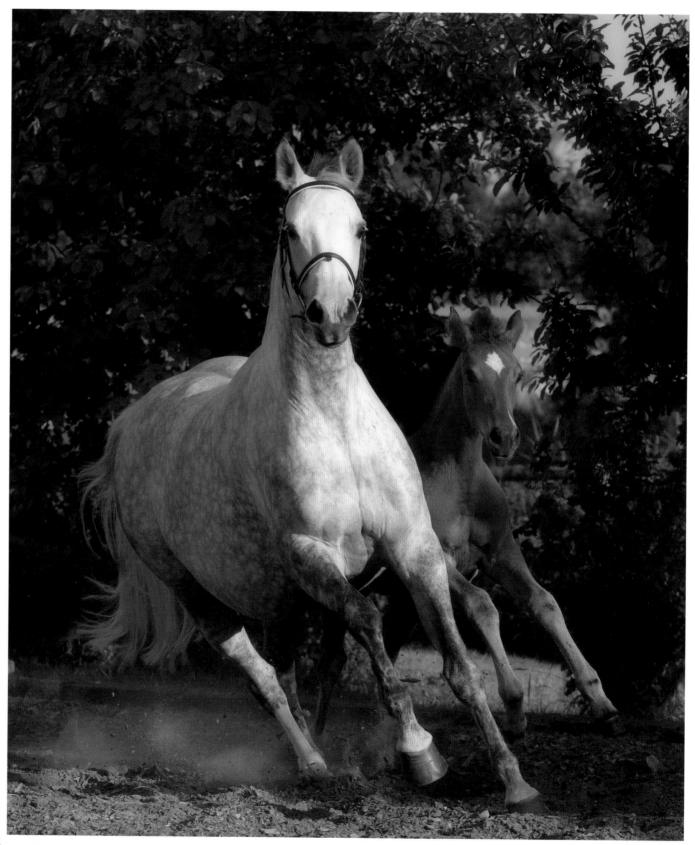

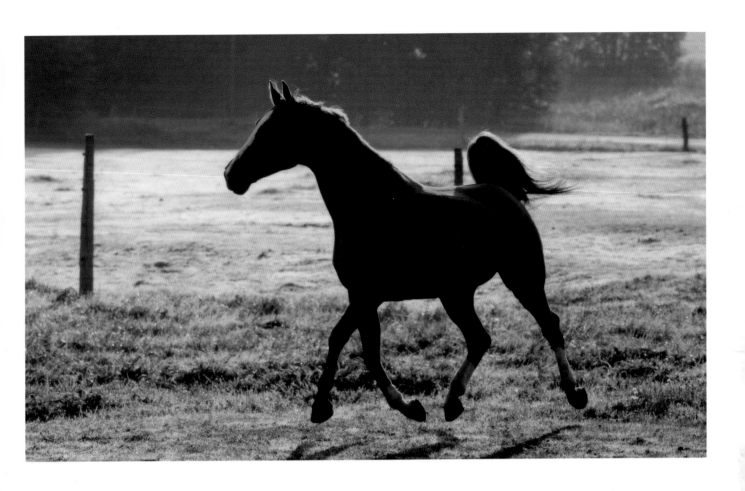

IN A TROT – IN A TROT
BID FAREWELL THE FAIRY QUEEN
YET TOUCH HER REALM OF DEWED GREEN NOT

When a horse trots or canters hundreds of pounds are set in motion with an ease that is to be marvelled at.

In a trot horses can float, and in a gallop they can lift themselves or stretch in long strides. Foals hold their place with ease cantering alongside their mothers. Or a day simply begins afresh.

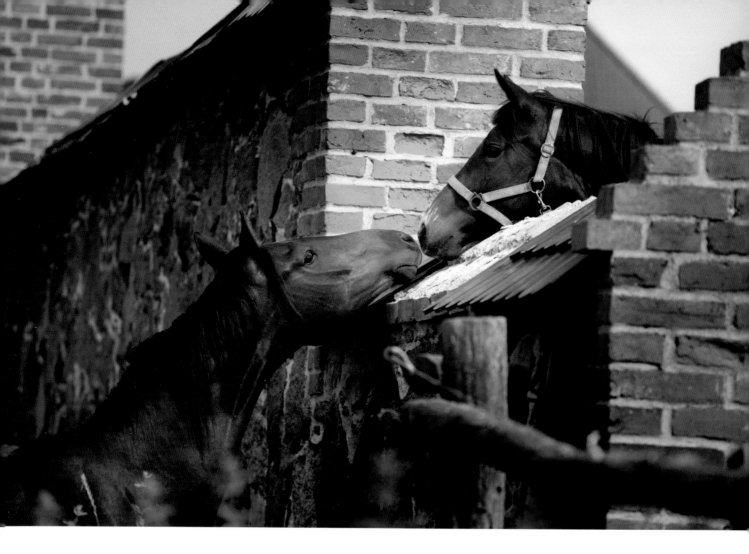

When I may watch horses left to themselves, I learn from them. Often, it is not a sizable discovery, in general it is only small bits that on their own have no great meaning, but put together they paint a vivid picture.

Sometimes it takes a very long time for one piece to fit well with another. Many still lie separate.

And some do have a meaning of their own. To watch the mutual inclination among horses – also the opposite, but time and time again the interest they show in one another – teaches me never to forget:

A horse cannot be at peace on its own. Being part of a group lends it the strength we so much admire in it.

This is the source of its tenderness.

LOVE
ALONE

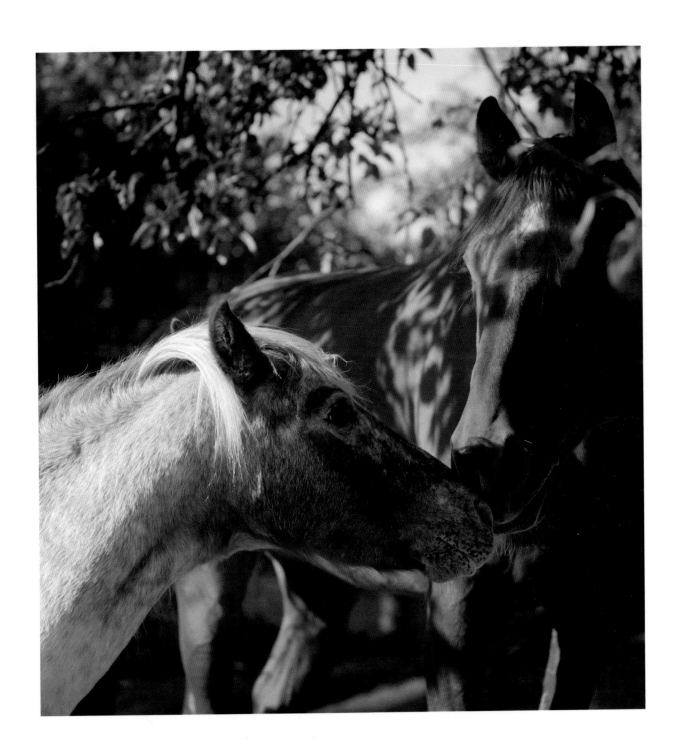

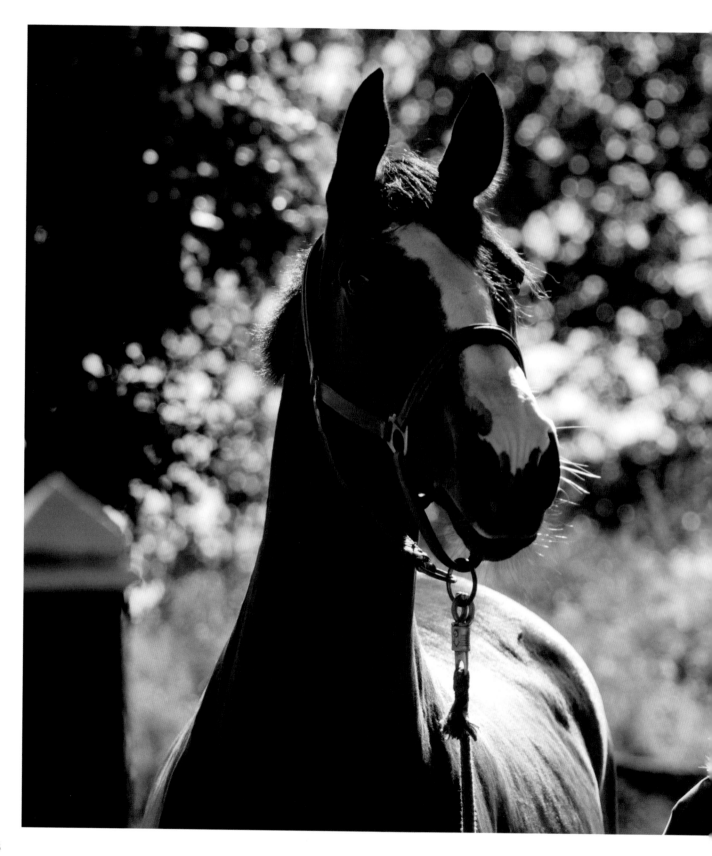

BEAUTY
OF THE MOMENT

The ability to be a friend dignifies the horse.

For centuries it has carried our civilization, and today it carries our dreams. And thereby it builds with ease bridges that span the oceans.

And it conjures a laugh into a beaming face.

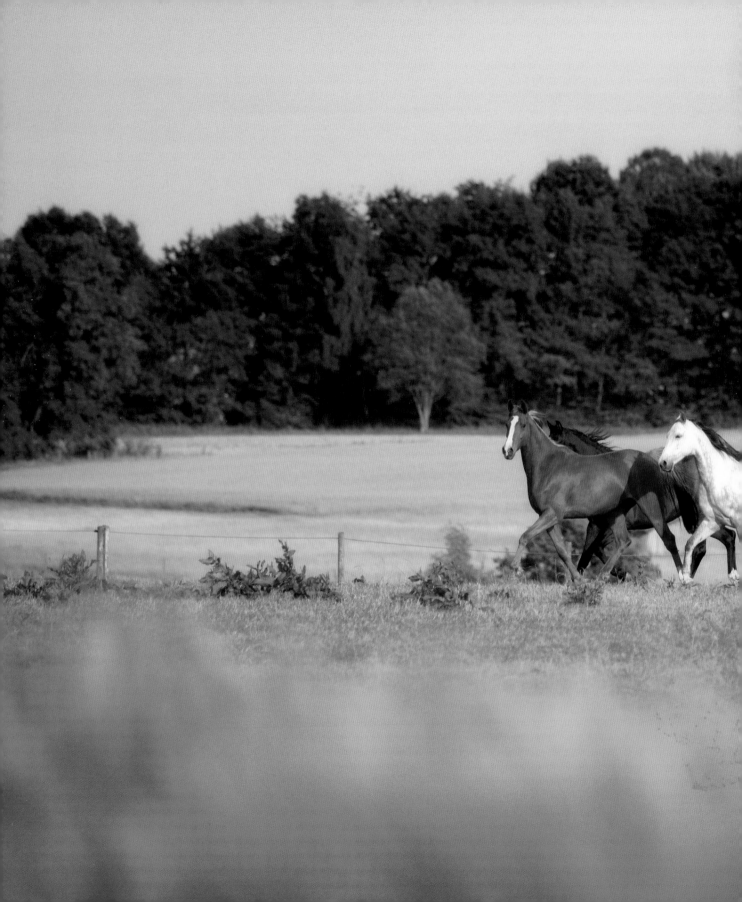

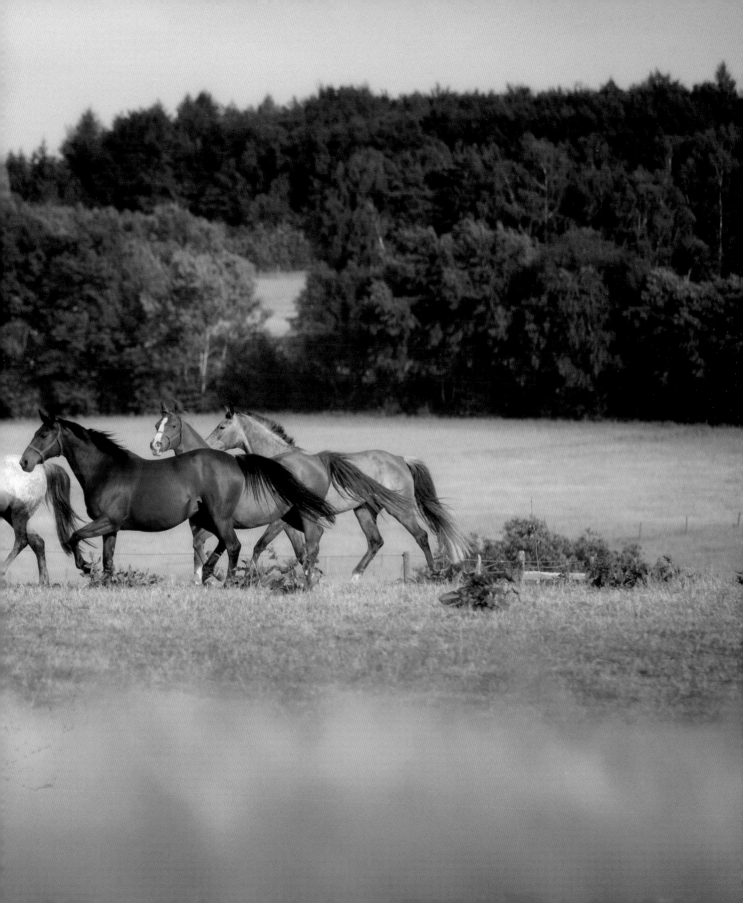

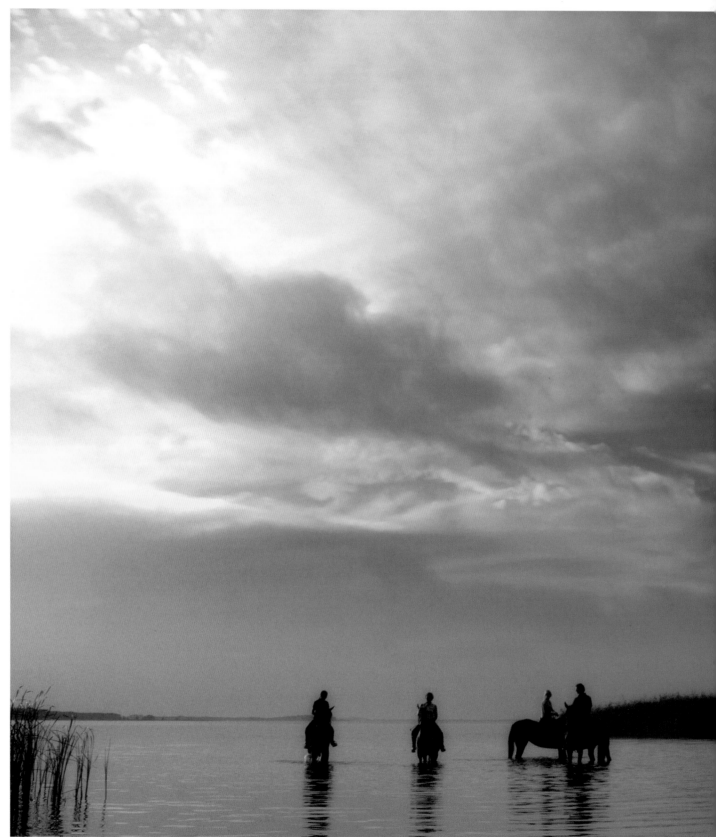

ONE OF
LIFE'S
GIFTS

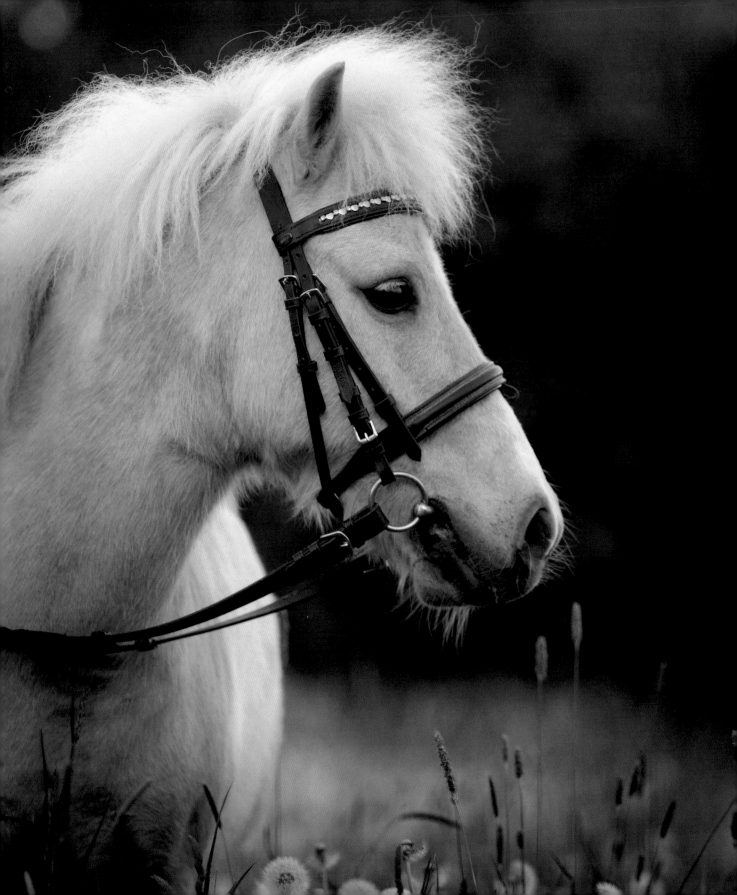

Whether Shetland
Pony or Westphalian,
whether standing not
even nine hands
small or almost
twenty hands tall:

In all horses there
beats a heart of
noble character even
though we tend to
grant this more
readily to the tall
ones than to the
smaller.

Both are horses and
they deserve our
respect and care to
the same degree.

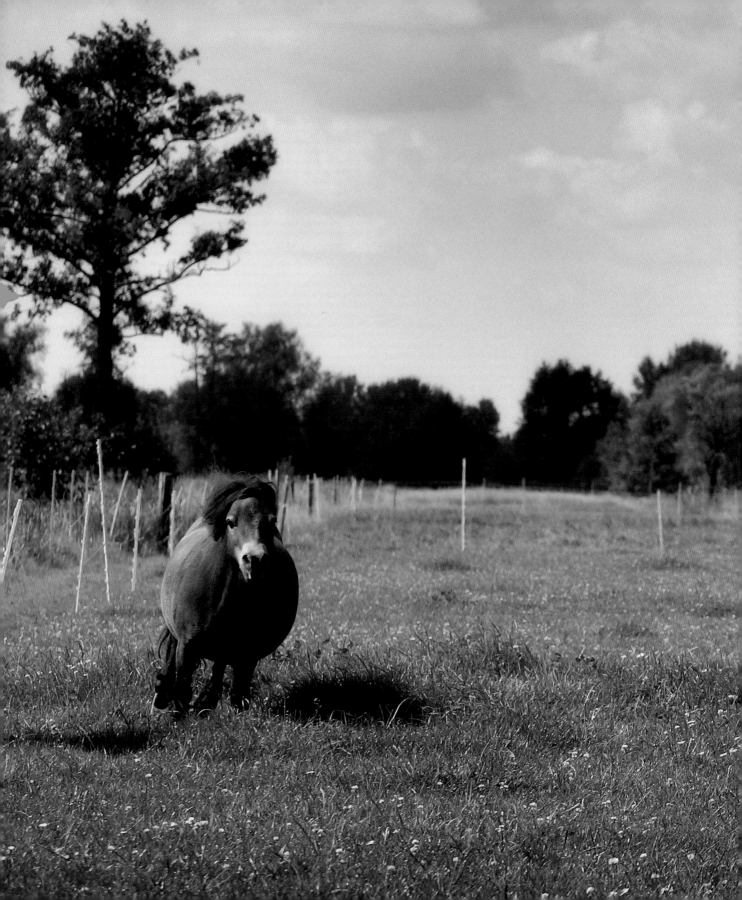

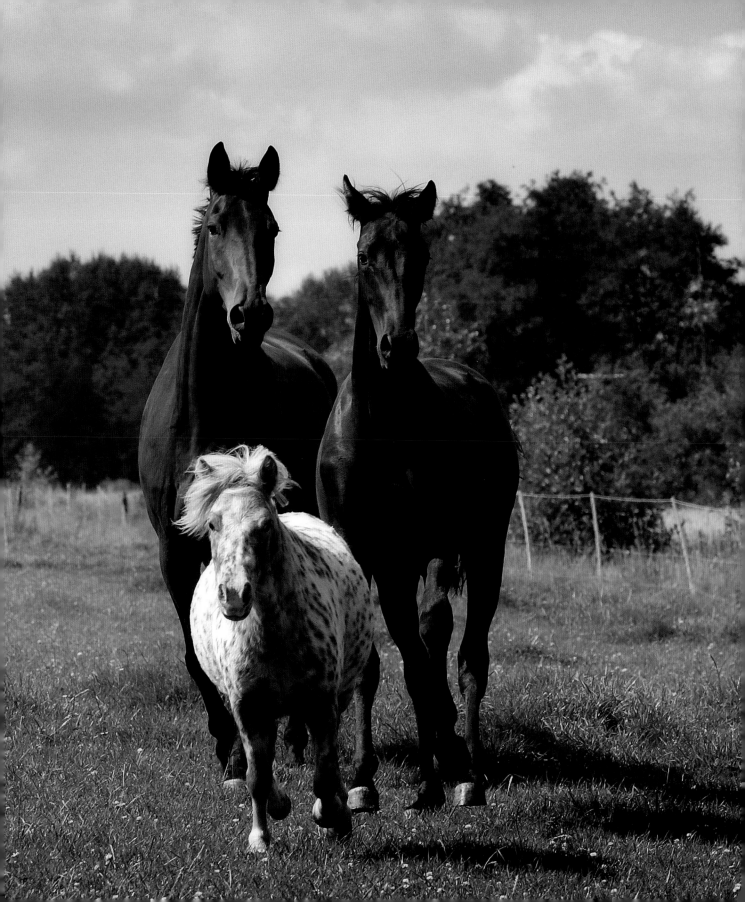

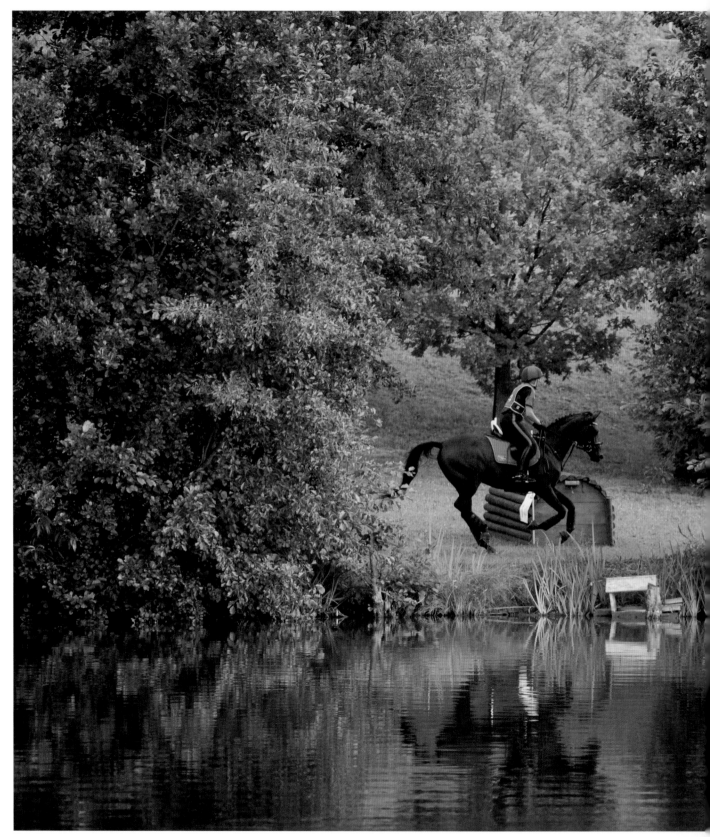

YOU
AND I

In the midst of a competition and yet in
quiet – two as one.

When horse and rider truly have found one
another, their partnership is beyond comparison.

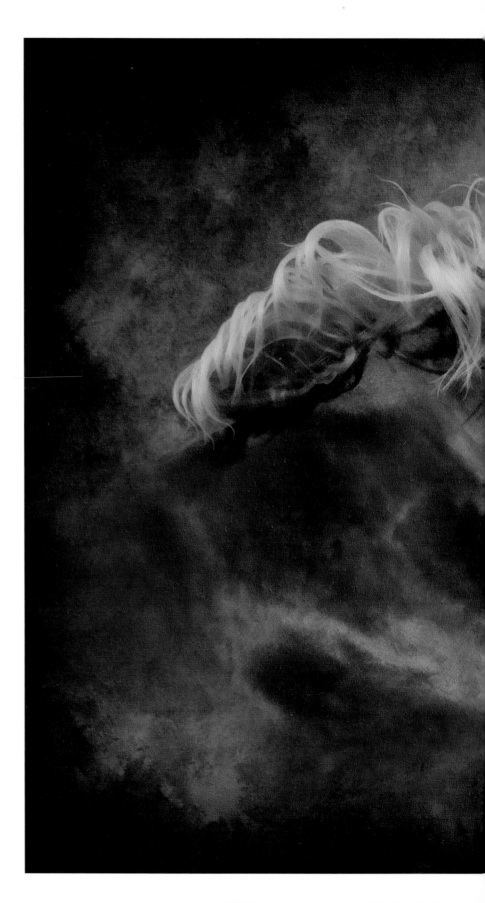

MIGHTINESS
OF THE SILENT
GAZE

Earth-shaking elegance. The powerful
beauty of a mighty draught-horse.

And yet I can only see its eye, its gaze
straight ahead, the sure confidence
in itself.

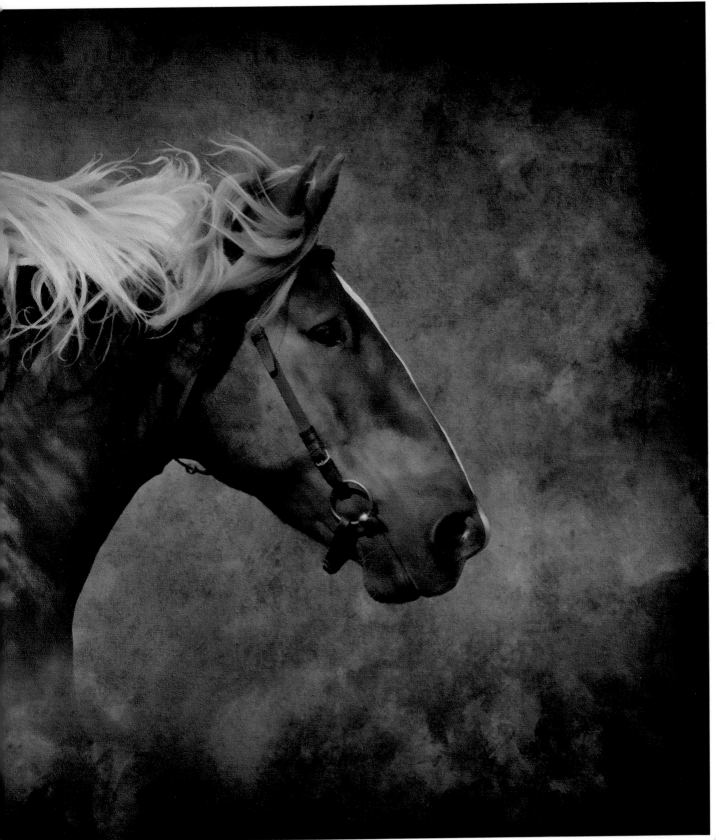

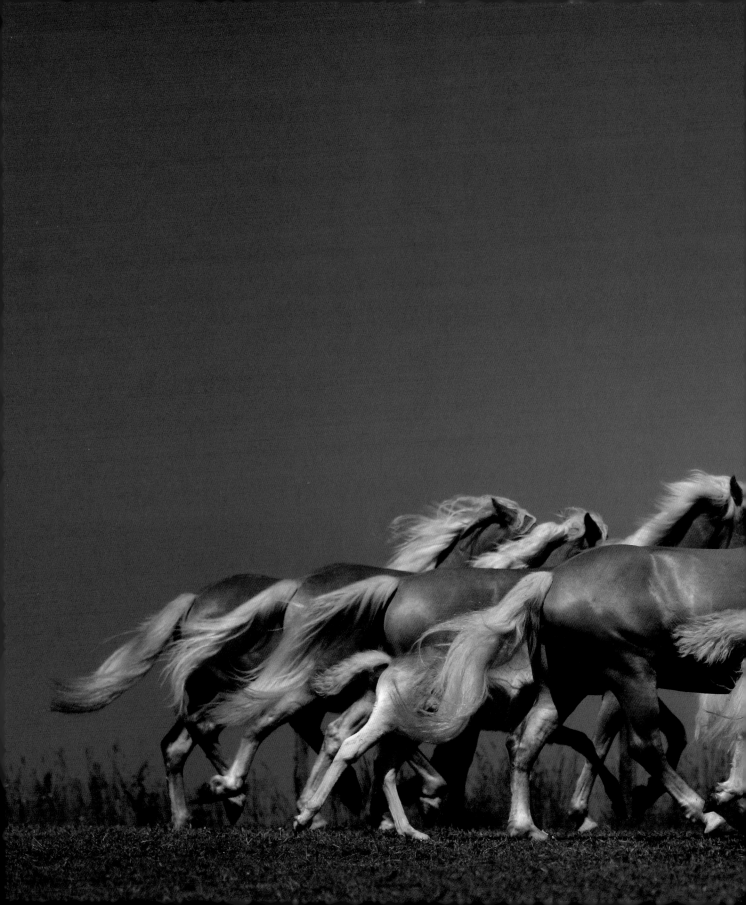

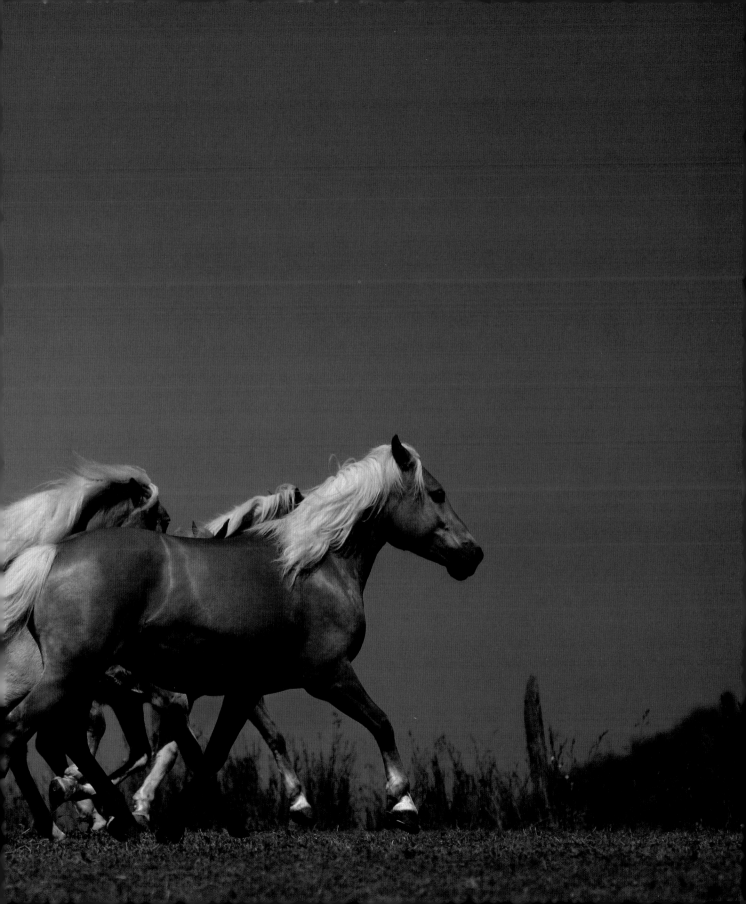

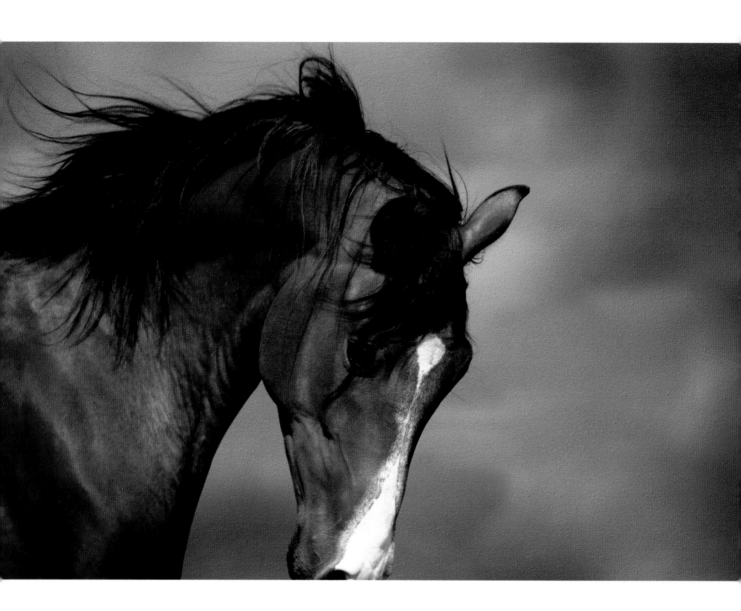

CHILDREN
OF ONE HEART

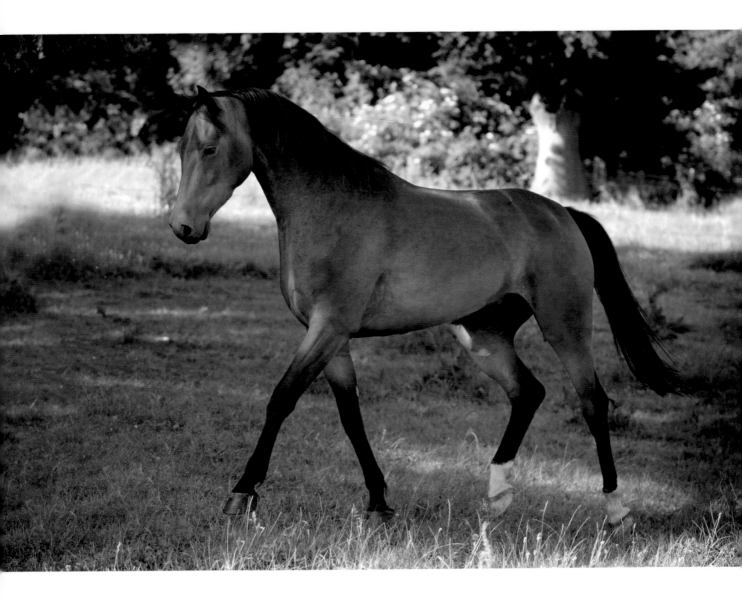

Some horses radiate their individual importance well beyond their appearance. They are the framework of their lives' surroundings, are more than friends to their people and lend a special glow to their world.

These two horses have accompanied me for years – each in its own way. They keep in their hearts the key to my happiness, and there could be no better place for it.

They have never met. Yet they belong together.

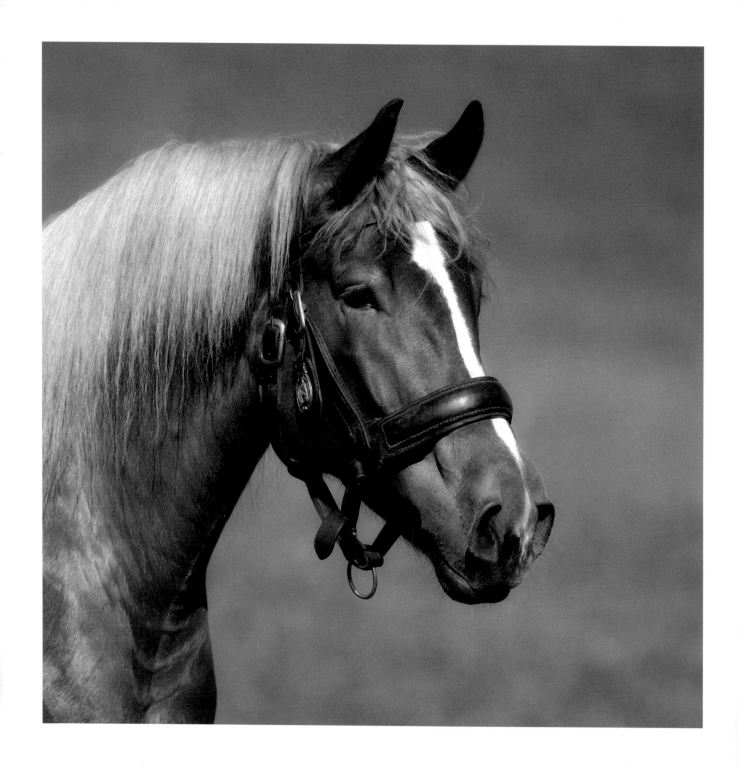

Nobility is no prerogative of the "noble races".

The beauty of a South German Draught-Horse is not the same as that of a Purebred Arabian.
But it is significant all the same.

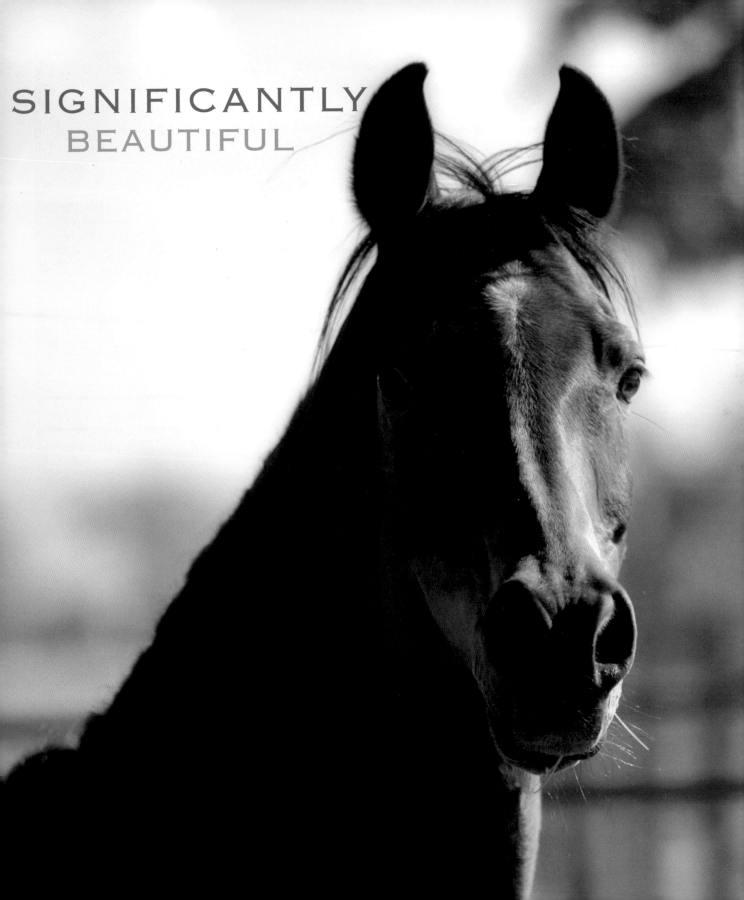

SIGNIFICANTLY
BEAUTIFUL

Motion is one of the basic needs of a horse. Running freely with others of its kind shows elegantly the joy it must have in its strength and speed.

And thereby it enriches our lives.

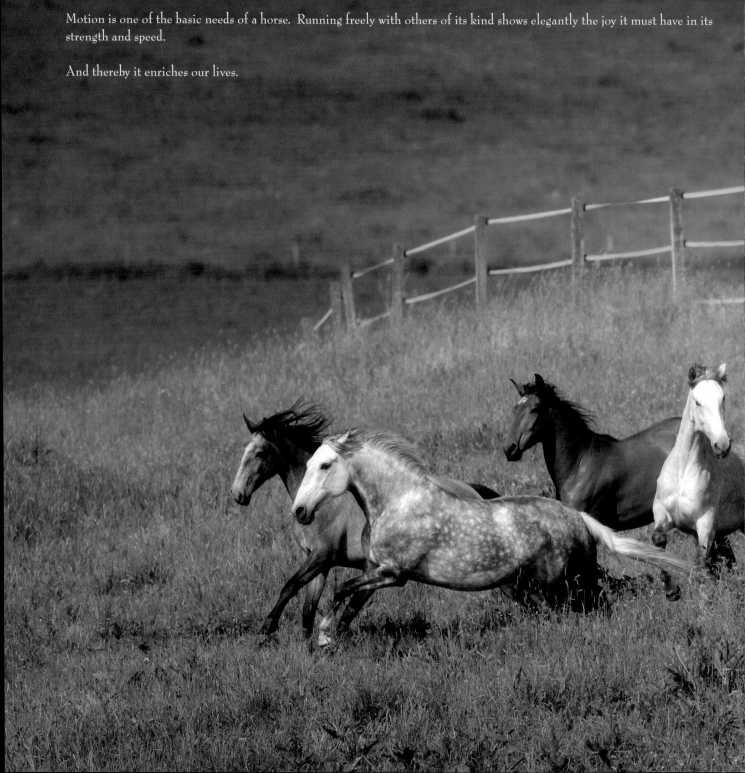

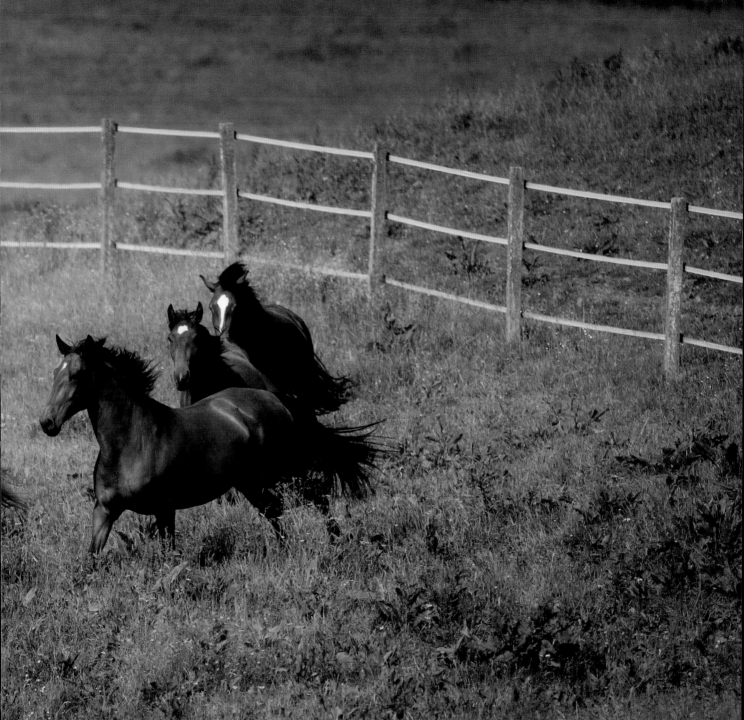

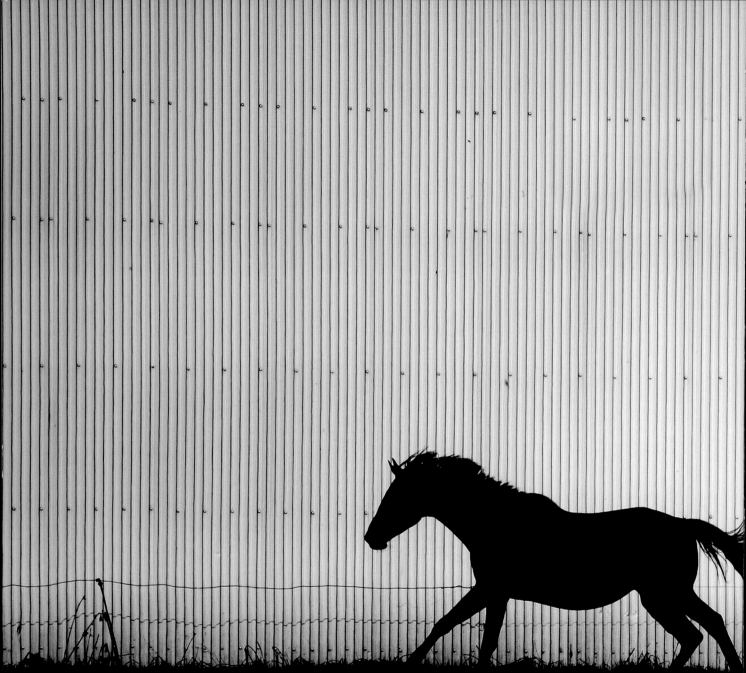

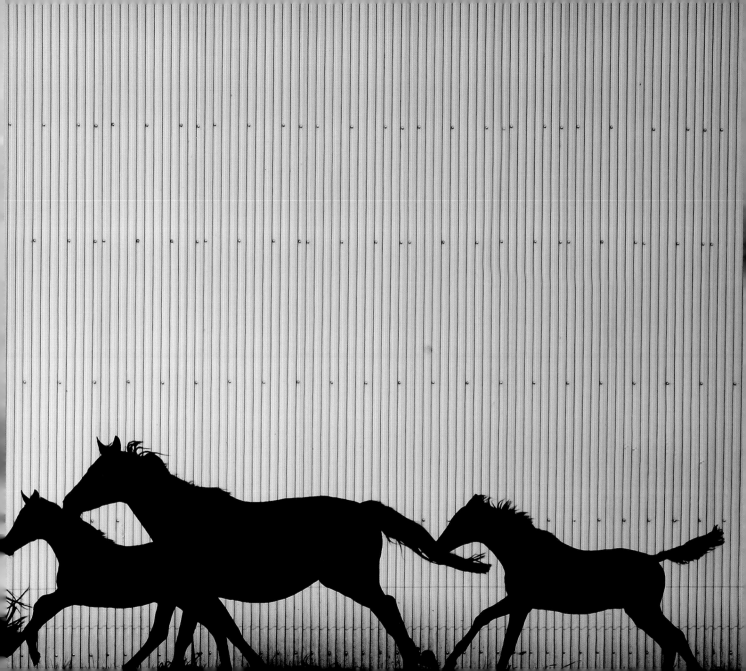

SHE WALKS
IN BEAUTY LIKE

THE NIGHT.

OF CLOUDLESS CLIMES AND STARRY SKIES

AND ALL
THAT'S BEST OF

DARK AND BRIGHT

MEETS IN HER ASPECT AND HER EYES

— Byron

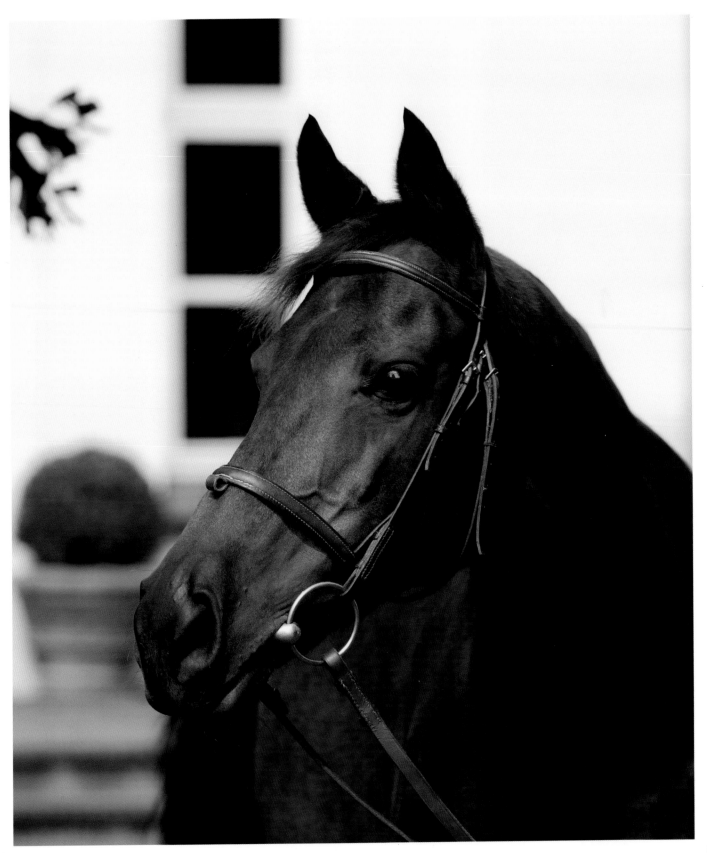

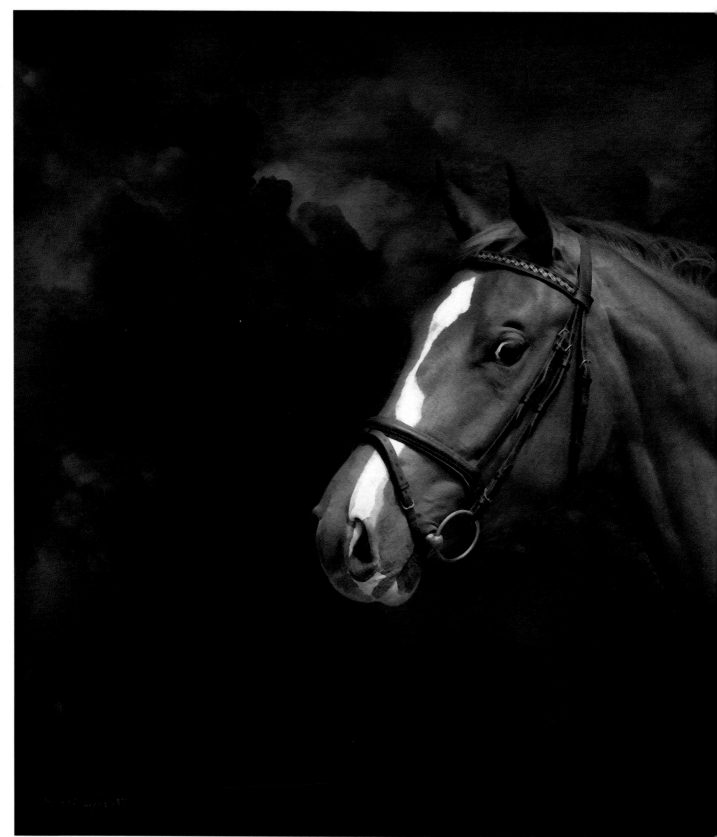

NOTEWORTHY
WITTSCHNUT

Unusual markings make horses distinctive.

What may be irritating at first can in time become
a real signature feature.

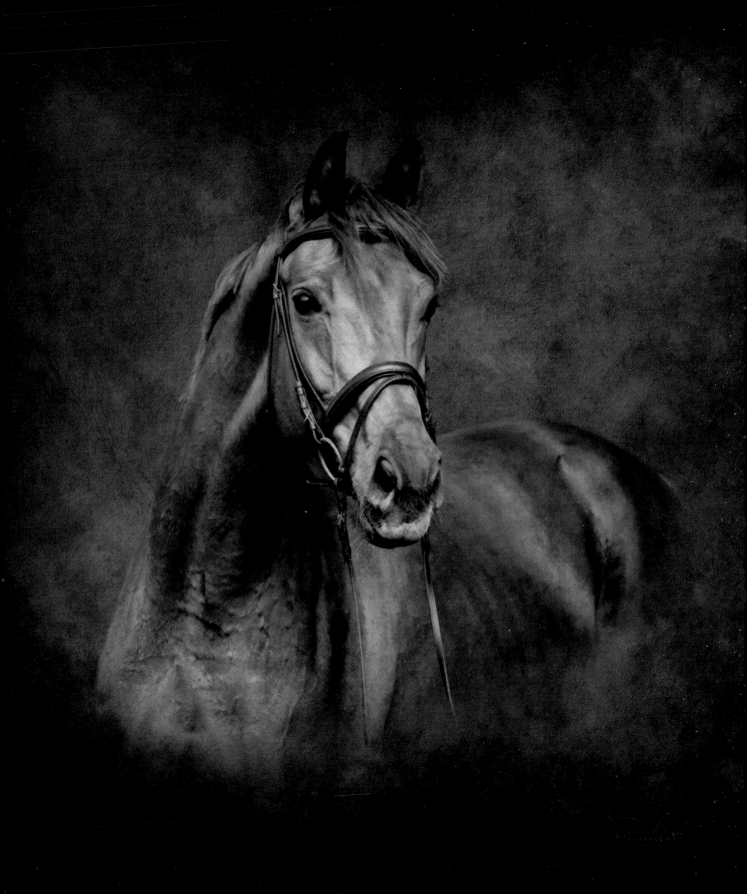

STRONG
POTION

The significance in the eye of this horse is difficult to put into words.
Its presence fills the space around it and claims all attention.

In some horses such magnetism does not merely slumber – it envelops them.

They are appearances that cast their spell onto anyone who sees them.

And Freixenet is one of them.

SHADES
OF UNIQUENESS

From the first day of the season to the last, surprises await us. The diversity of the equine world is practically inexhaustible.

Sueño is a Criollo and it was not just his breed that was a first encounter for me – I had also never before photographed a horse of his colouring.

He came to Germany aboard a great ship from South America – and I can't help myself: I am swaying between recognizing the familiar I see in all horses and a pointed exoticism. Does it have to do with the story of his travels? Or is he a horse just like any other?

But: "A horse just like any other?" What does that mean?

Sueño made me think:

He may look significantly different from the horses I have worked with in the past, and that makes it more evident, but uniqueness is, after all, to be found in every horse.

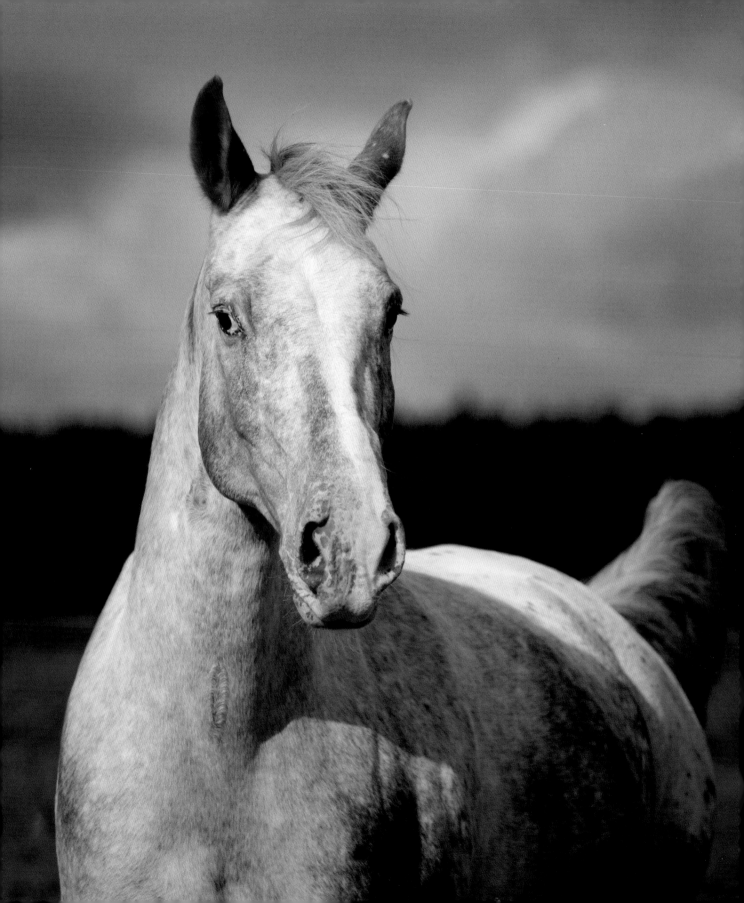

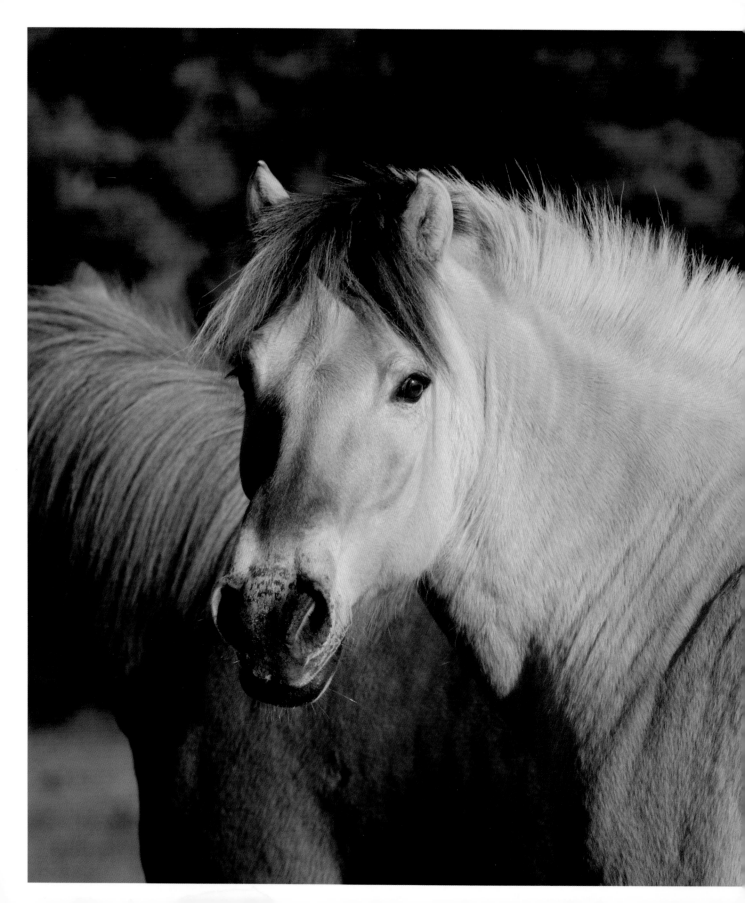

FRESH
AND FREE

With horses as your friends each day is a new adventure. Perhaps they show us a new side of themselves, or they are our partners in exciting expeditions.

A life with horses has many facets, but tedium is certainly not one of them. A day in a life with horses is always fresh and new.

Like the drops from the dew-wet grass on Chico's nose.

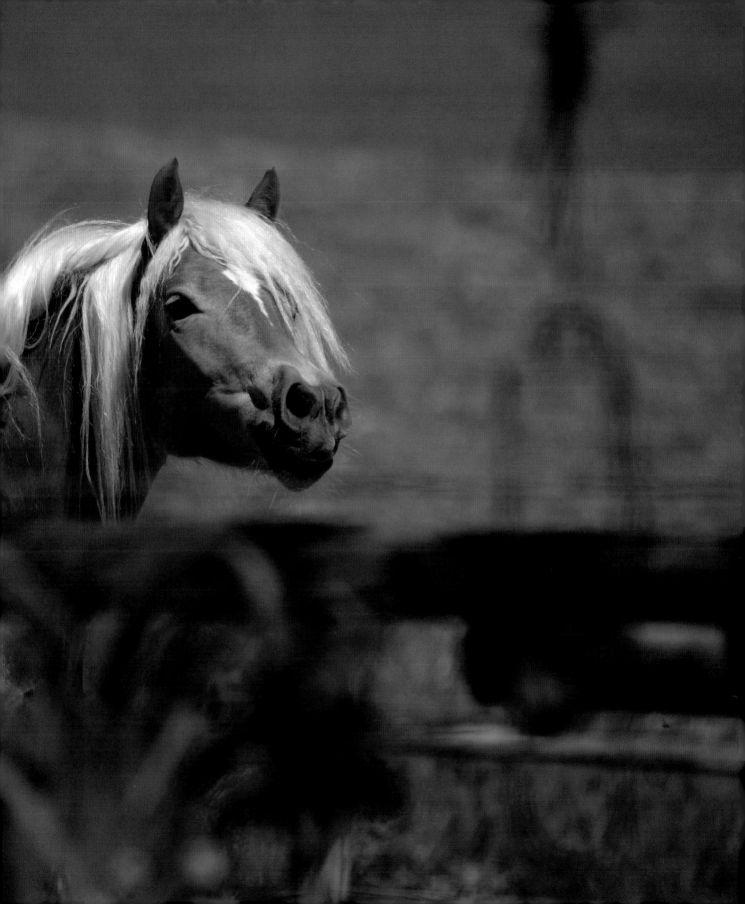

NOBLESSE OBLIGE
A GOOD HORSE
HAS NO COLOUR

There are many horse breeds of which we have a certain picture in mind. We see a horse and are immediately able to tell its breed.

Lipizzaner. Friesian. Haflinger. Very simple.

But the brown overo? It's a thoroughbred. In America, colourful and marked lines are highly esteemed, in Germany uni-coloured horses represent the general notion of an elegant horse. The fewer the markings, the "better".

But blood is not blue. And the highest nobility may cloak itself in colour.

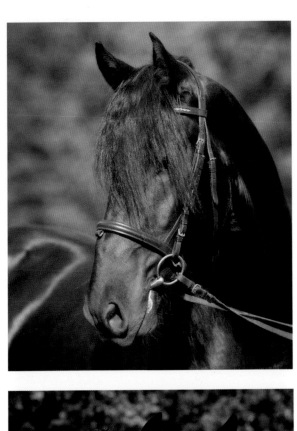
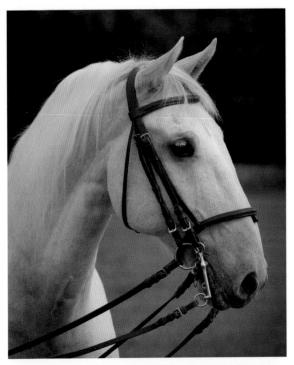
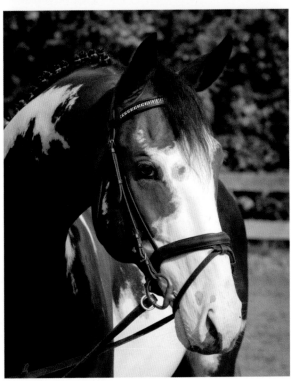
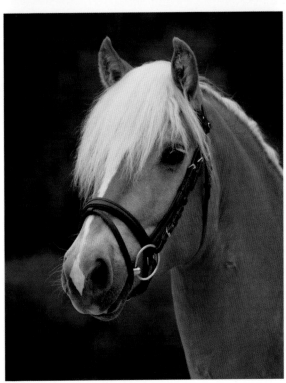

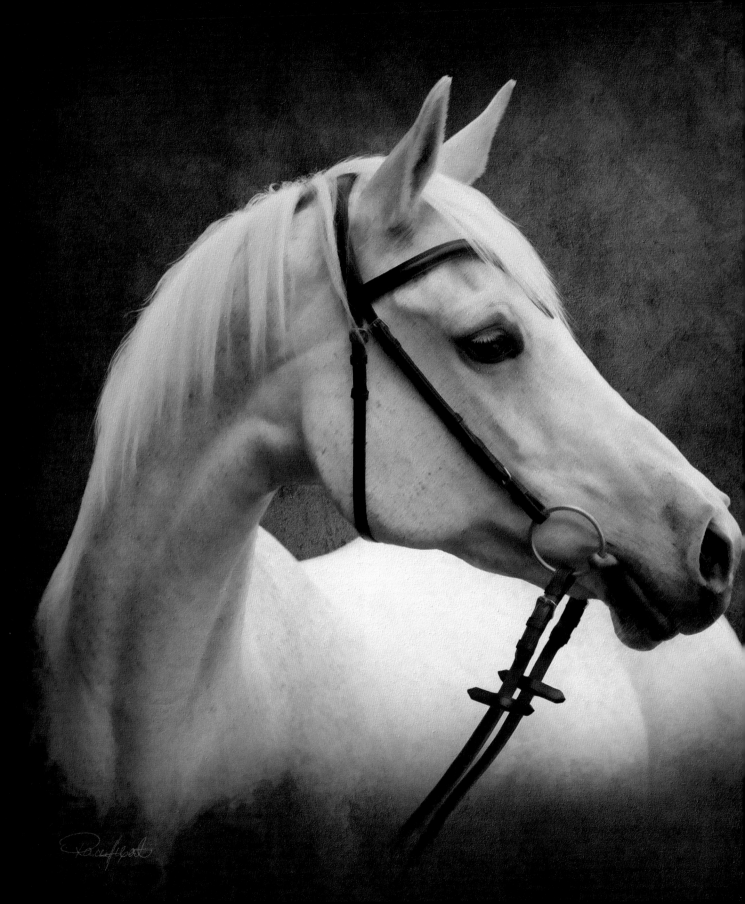

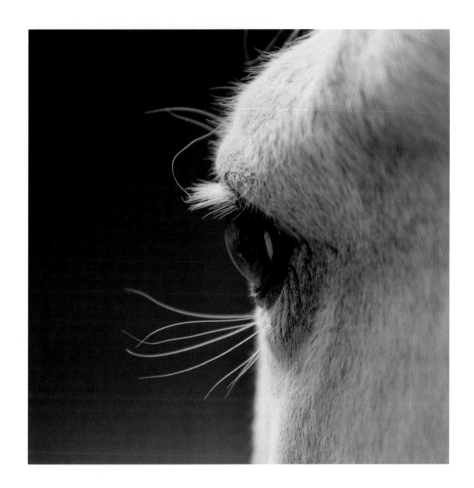

Greys have cast a special spell on me. While I love the play of all the coat colours, with greys many features of a horse are reduced to the fundamentals and this lets me see deeper immediately.

White is the colour we owe to the Arabian horses. At the heart of most horses you will find some part of the desert as an element of their heritage. With greys it may be just one grain of sand more.

Elegant like a wind-blown dune. Beauty a-walking.

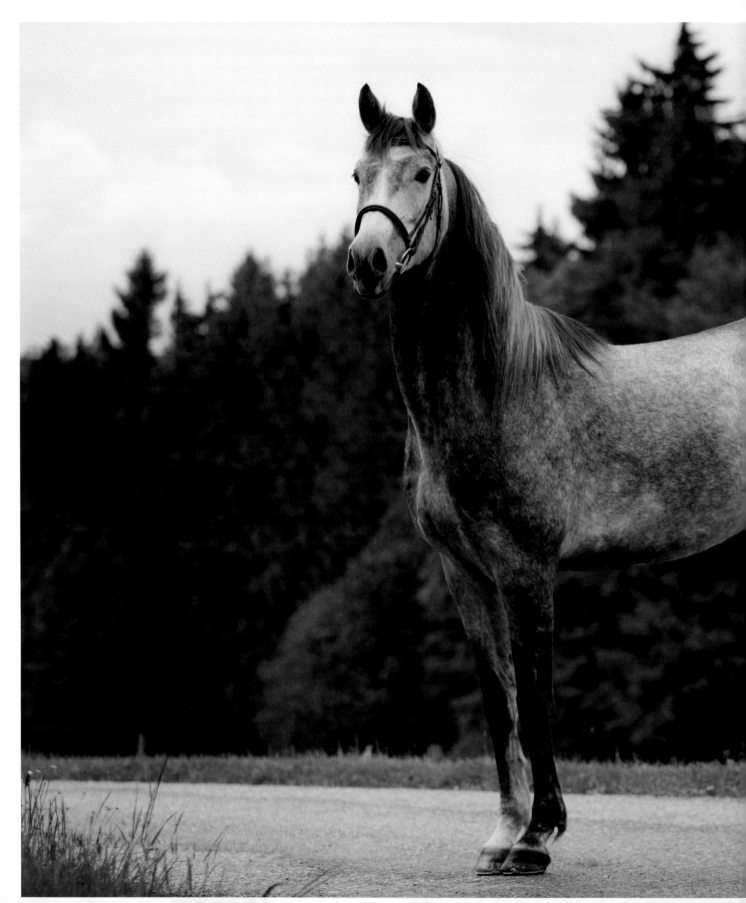

ANGEL
ON A VOYAGE

For many of us horses are a bit of heaven on our earth. Their legs lend wings to us, they soothe our pain and sorrow, they bring joy, and they give us shelter from the fears of the world.

And some horses have the gift to enchant us more than others.

It was merely a fleeting instant I worked with Bohdana, but when she looked at me, all else around us sank into irrelevance. We shared only a few moments of time, but the memories of it are endless: Bohdana made me a gift of eternity.

Five days after this picture was taken Bohdana herself went on to eternity and took a part of this world with her. When I was told, it broke my heart. A part of it followed her, and the scar that is left with me is like the memories of that day – without end.

But this is nothing in comparison with Bohdana's gift of infinity.

QUO
VIDES?

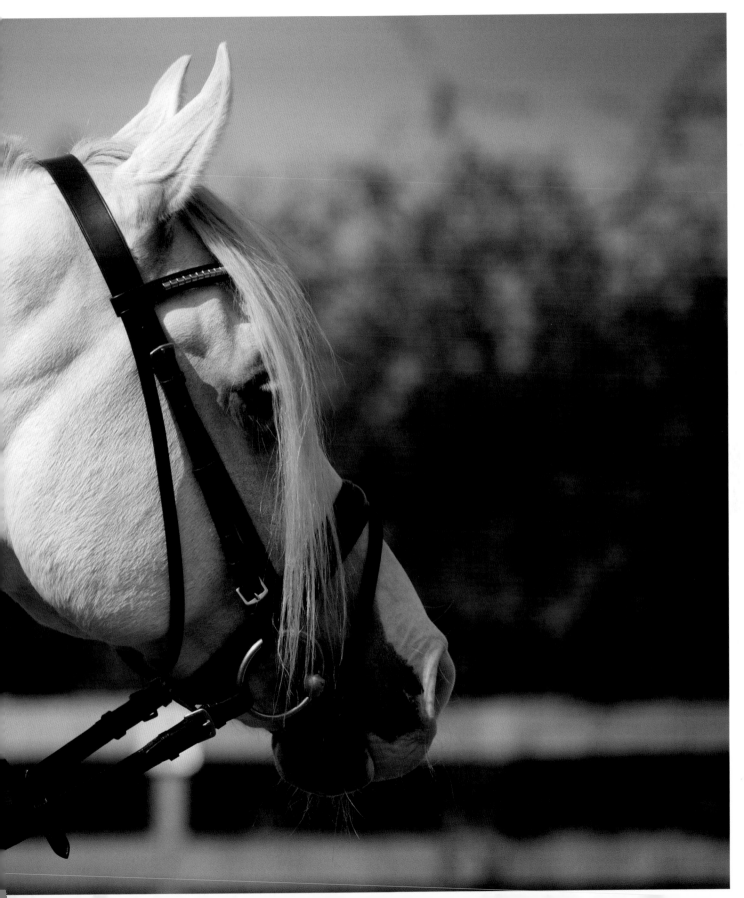

CHARMING FATHER FIGURES

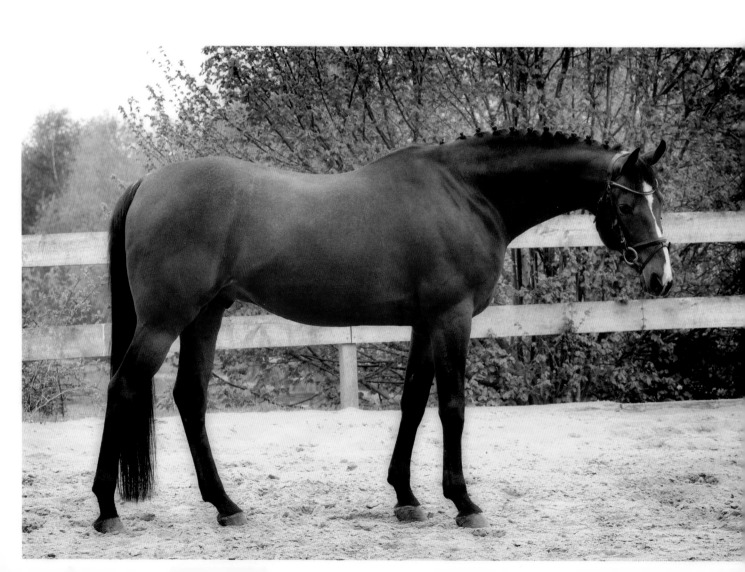

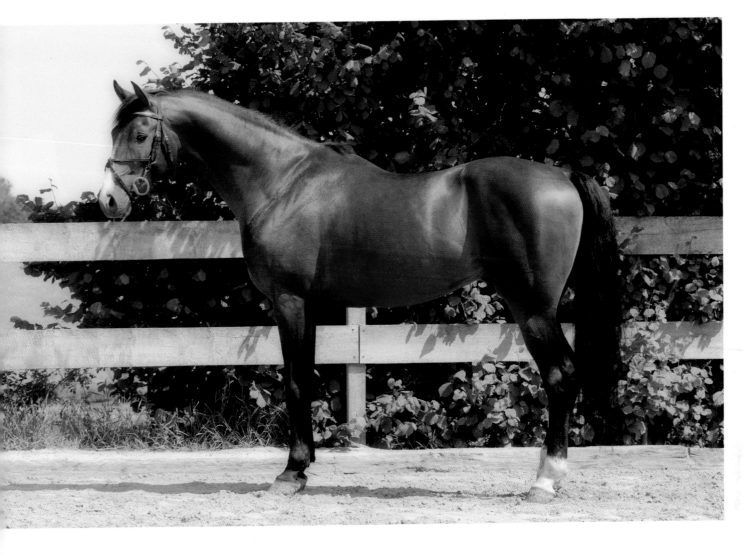

Stallions live very special lives in our care. Due to their natural behaviour they usually cannot spend their "spare time" out in the meadows with other horses.

In general, their daily routine runs along strict lines – especially when sires present themselves to a photographer, which is supposed to be done in a certain standardized way. And with good reason, because breeders who are looking for the right stallion for their mare want to be able to judge his physical qualities from a picture. There is more to be taken into consideration, but this is usually where it starts.

I delight in horses that at times prefer to show us a glimpse of their character instead of simple standard behaviour. And so I, in turn and for once, prefer to show a picture that shows a stallion in a way different from textbook fashion.

Character is so important in considerations of breeding, and coming to that, I would hand over the care of my life to any one of these two stallions. And I would gladly spend time in a meadow with them.

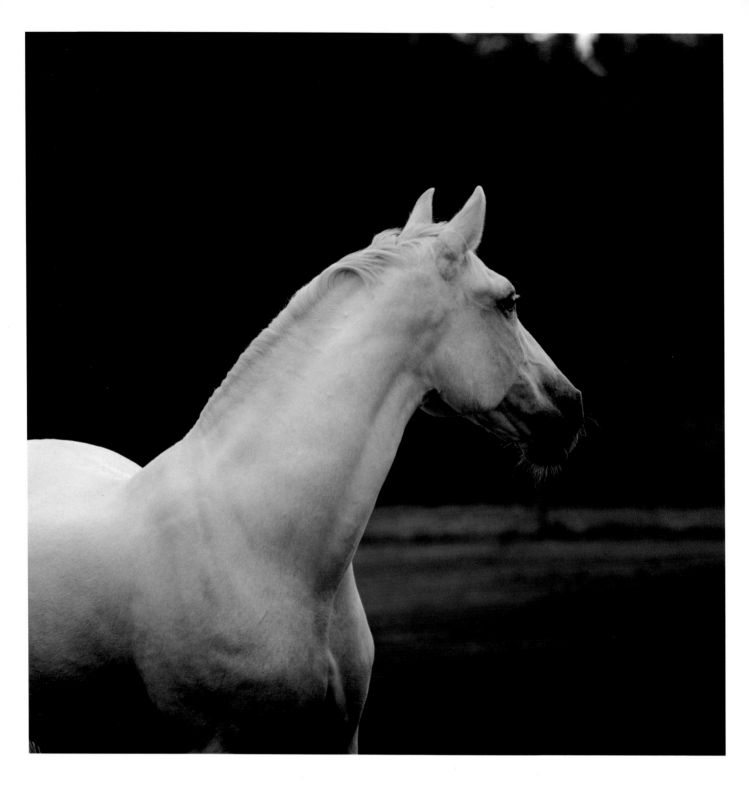

DIGNITY
OF OLD AGE

Even though strength, stamina and elasticity decrease in time — one thing gains in intensity to the last day: the telling gaze.

And when this seems to show nothing but emptiness?

Does that not tell us a great deal? Does that not pose serious questions?

These two horses, one well beyond 20 and the other 32 years old, possess a knowing look of pride and self-confidence.

No emptiness. No unanswered questions.

They are safe and sound in loving care.

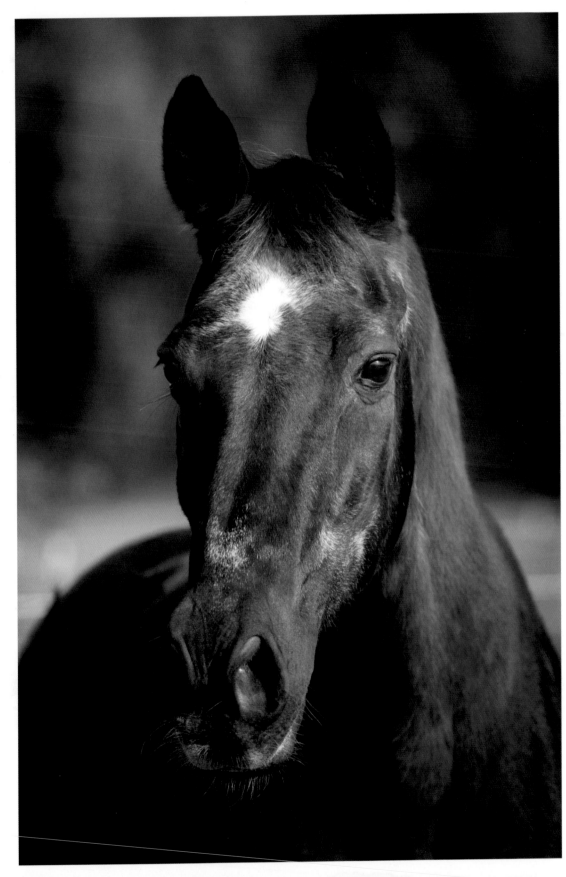

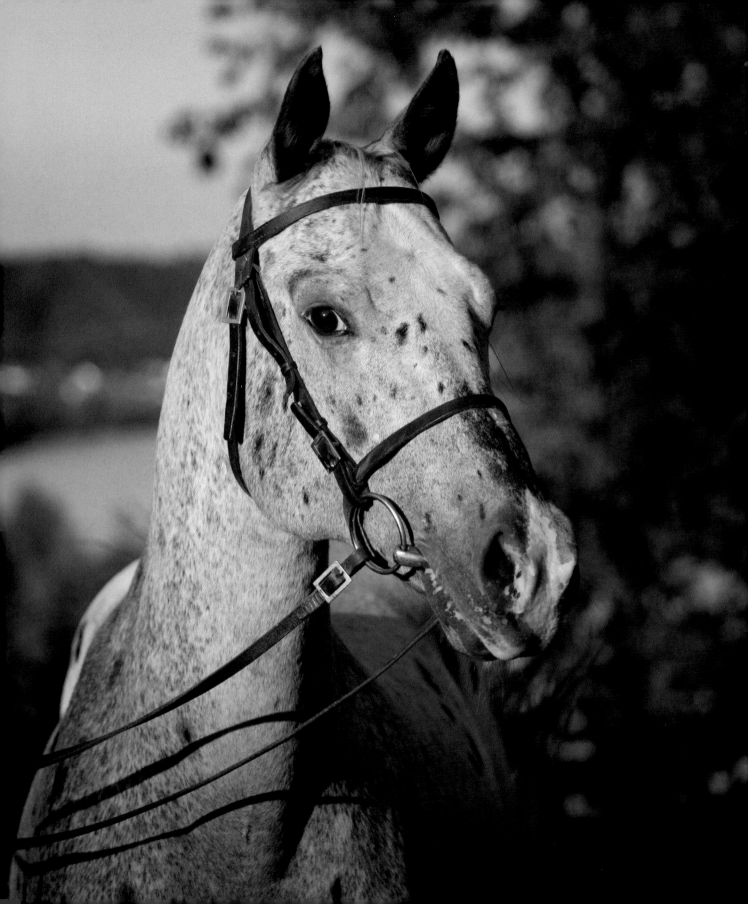

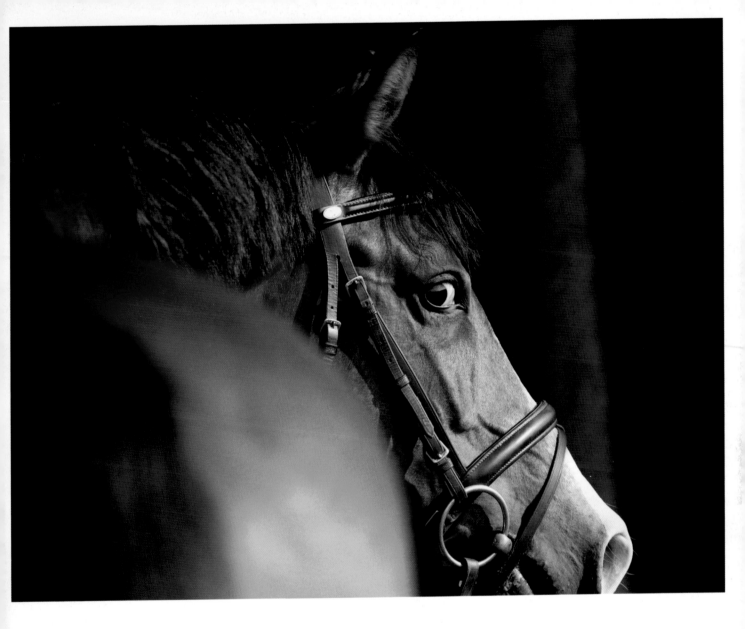

A signature feature of many vividly marked horses: the human eye.

I have once heard a trainer judge a horse to have a poor character because of such an eye. That is nonsense. It is simply a colour trait. We can only learn to judge a horse's character by spending time with it – and by watching it.

Those who stick to appearances alone may easily overlook the essential:

Nobility, dignity and beauty are more than the sum of good looks. The quiet elegance comes from within.

BEING
ONE

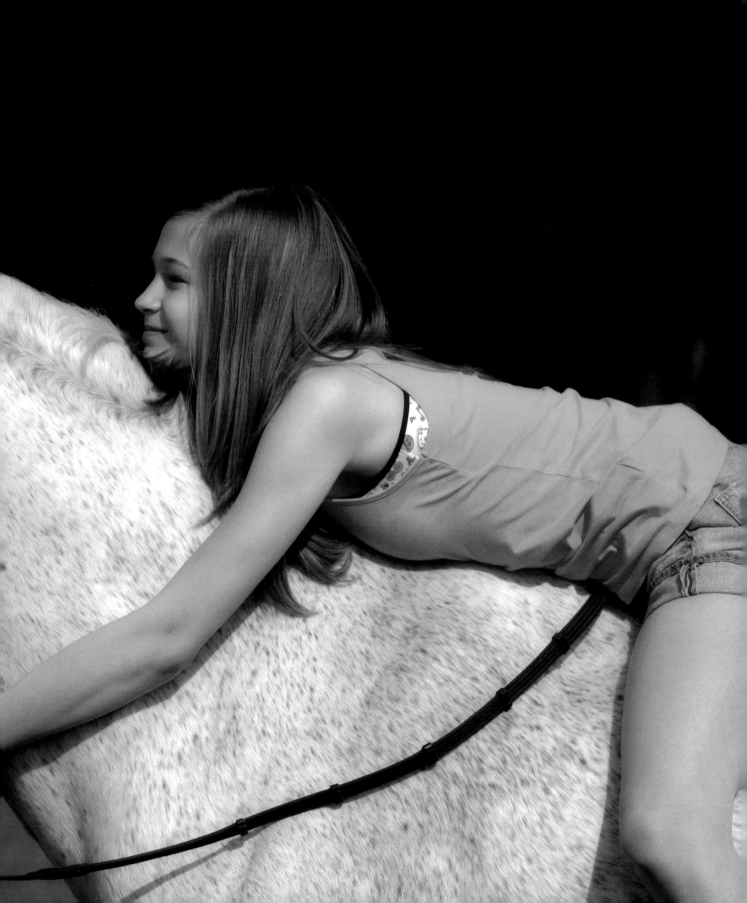

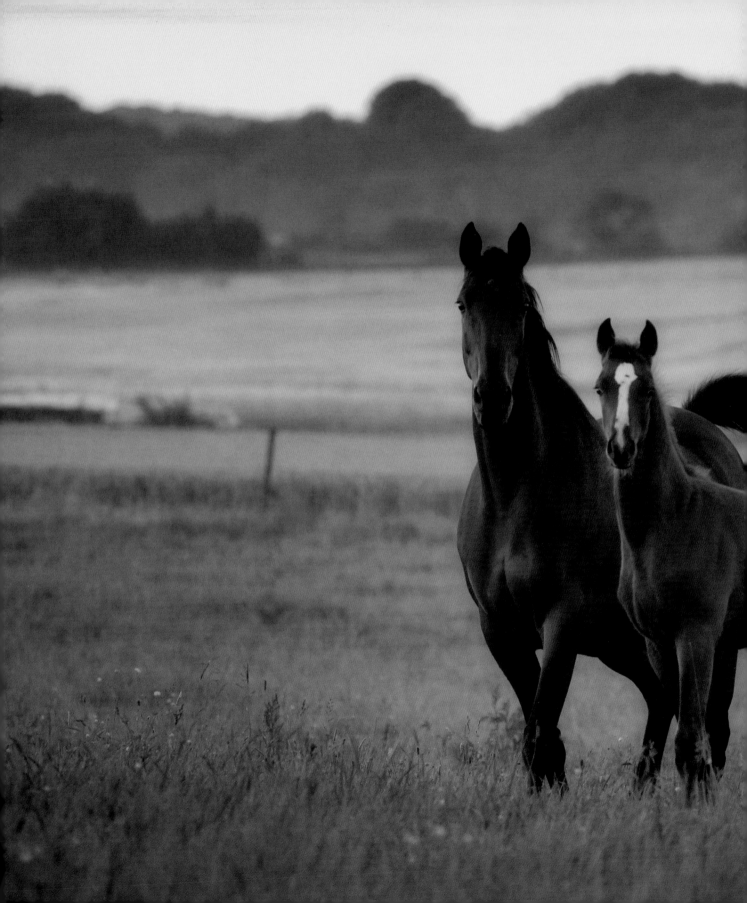

With the morning sun hope rises to the horizon.

Hope of joy, happiness, fulfilment. Horses give much of it abundantly. They share their lives with us, and some give it for us.

And they pass their noble essence on and on. From many faces it looks at us as one.

MAGIC
SPELL

Horses communicate among themselves differently than
we do with language.

Certainly – they do use their impressive voices and they
do have a very communicative body language that we may
learn to understand. But there is more.

When horses move together – be it walking, as shown here,
or at high speed – they seem to be able to join their minds.

Horses commit themselves to one another differently than
we do. There are times when they invite us to join them,
however. It doesn't happen often, and these moments pass
very quickly, but anyone living with horses knows these
instances of a very special magic.

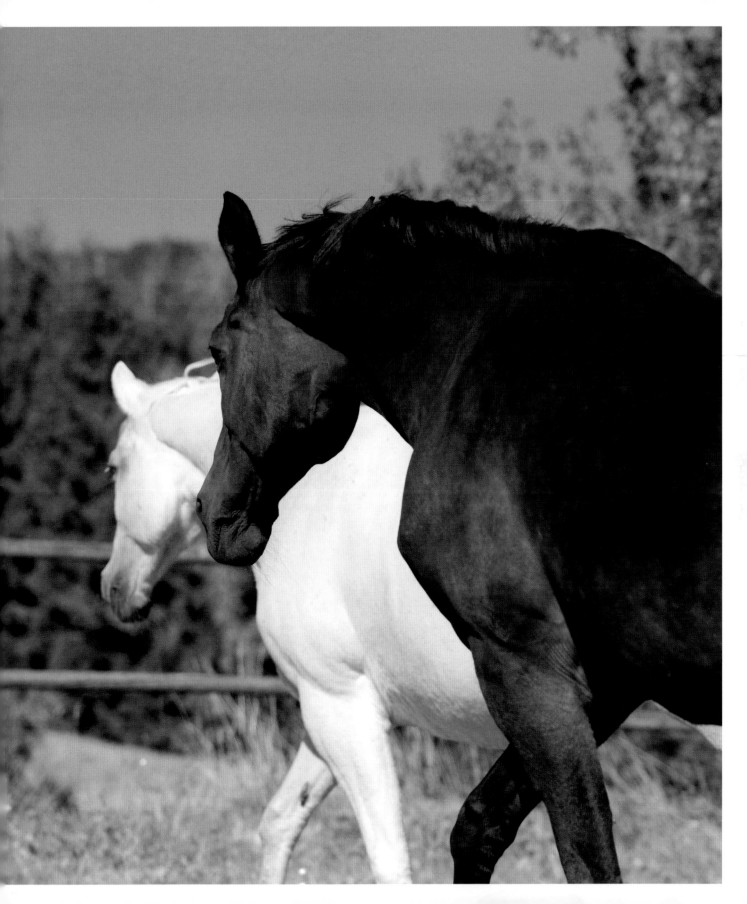

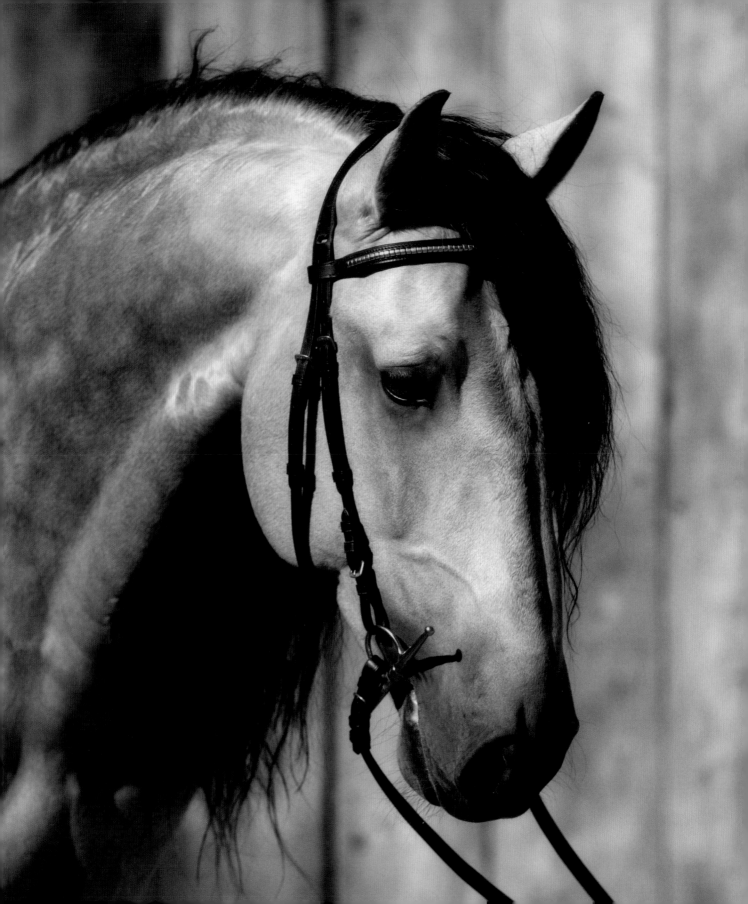

In quiet moments lies the power of great impressions.

The tender gaze of a true friend and the return to the barn.
Retrospect. The prospect of yet another beautiful tomorrow.

The confirmation to have done right in the decision to spend a life with horses.

AND
ALL
IS
WELL

SUN'S
GOLD

Some moments are of such meaningful beauty that they last longer than their actual time.

We find nobility, dignity and beauty in all horses, and sometimes we are almost blinded by them – as if we were looking directly into the sun.

Kasirah has spent much of her time in the shadow of one such moment, but anyone who takes care and looks into her heart will find the shimmering gold of the sun within this mare every single day.

Its rarity makes gold so precious.

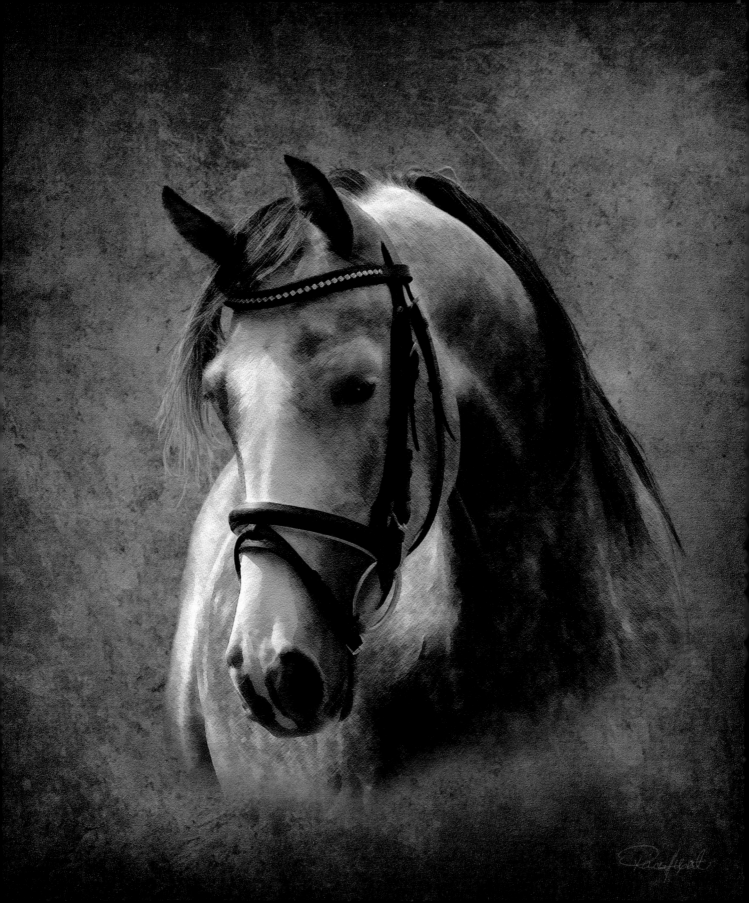

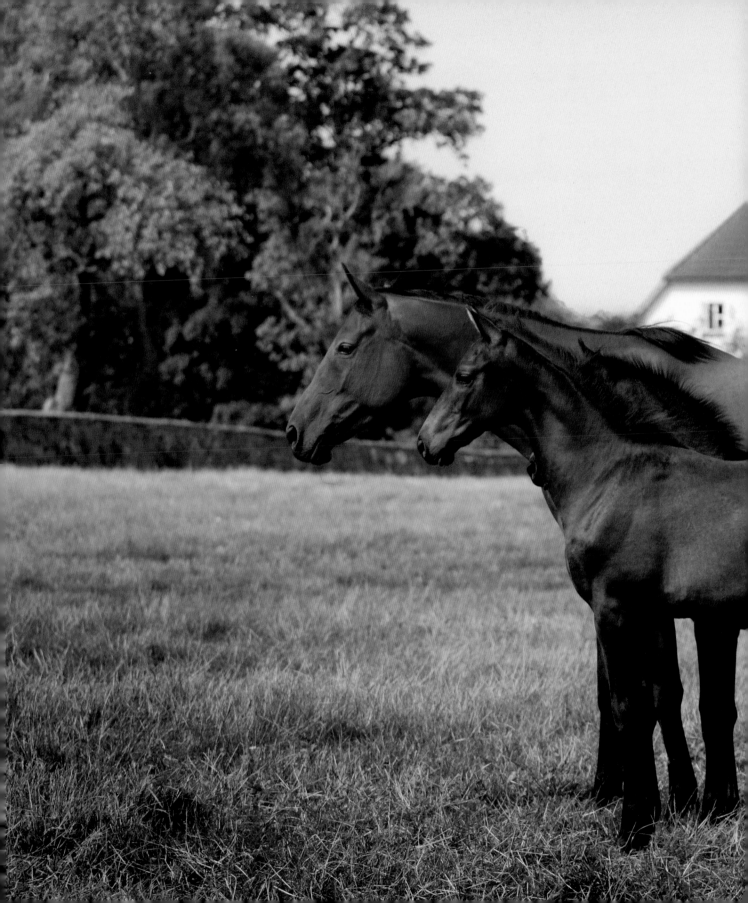

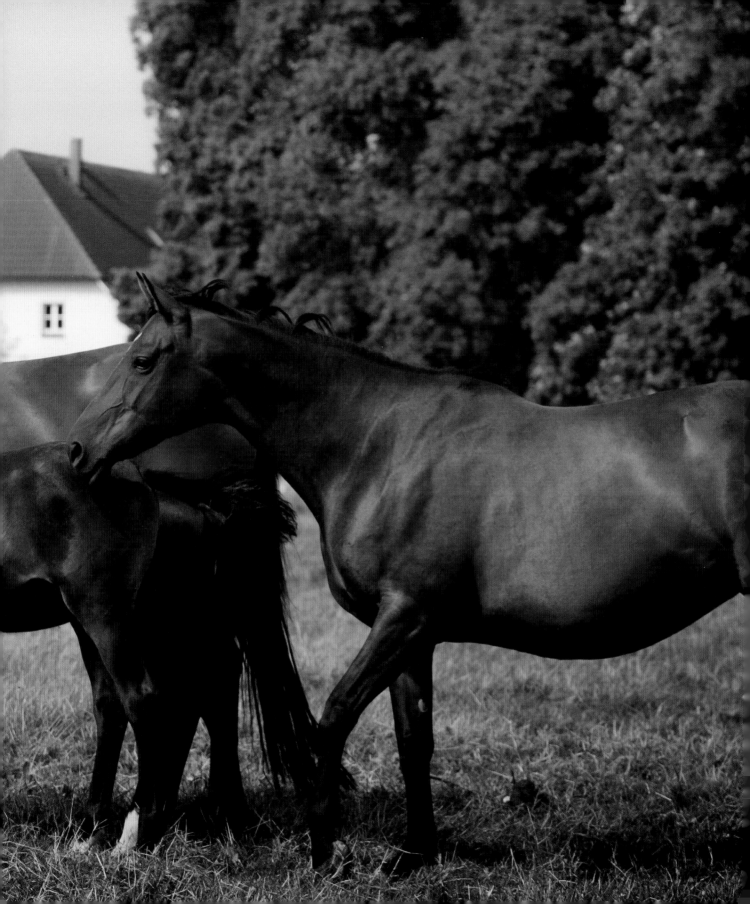

ENDLESS

When a horse casts its spell on us, our
worries of time disappear, because in its
realm different rules are to be obeyed.

Its realm is one of width, of depth, of
space. And its boundaries lie beyond
the horizon.

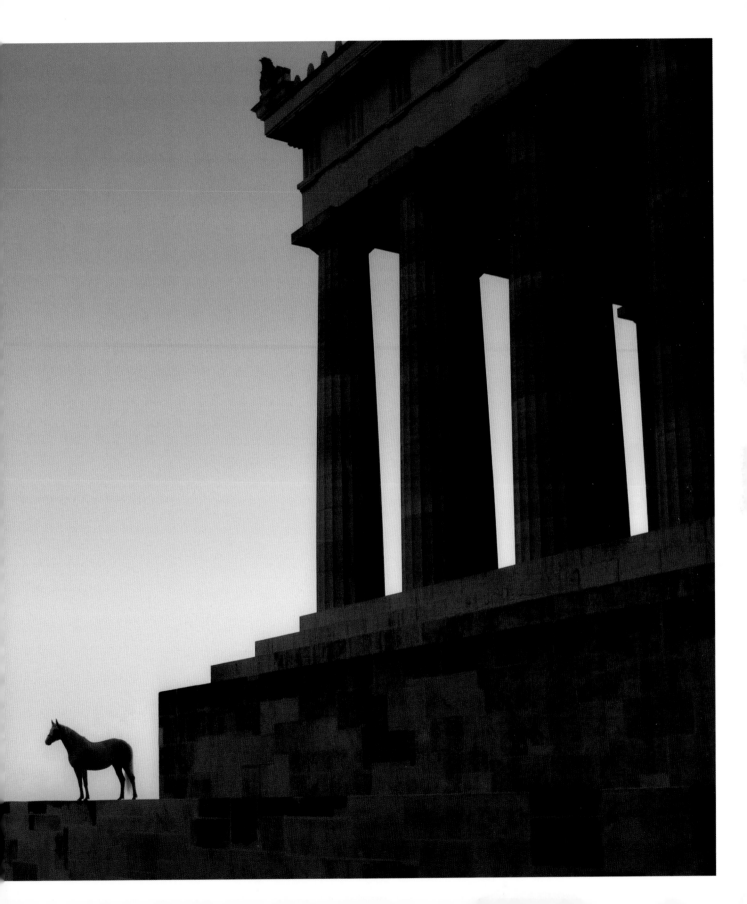

ALL FRIENDS

Our horses are not free. They live in our care, have and are friends. They are respected personalities and we should know them as such.

In producing the pictures shown in this book no horse – especially not Luz on the steps of the German Hall of Fame, the Valhalla near Regensburg – was ever put at risk of any harm, and no horse was handled in any but the most respectful manner. I love the joy and the interest of horses, not their fear, and it is far from anything I would ever do to call for anxiety or panic in them. No picture is worth the discomfort of the creatures we love. With the exception of the back cover of this book no image is the result of artificial composition.

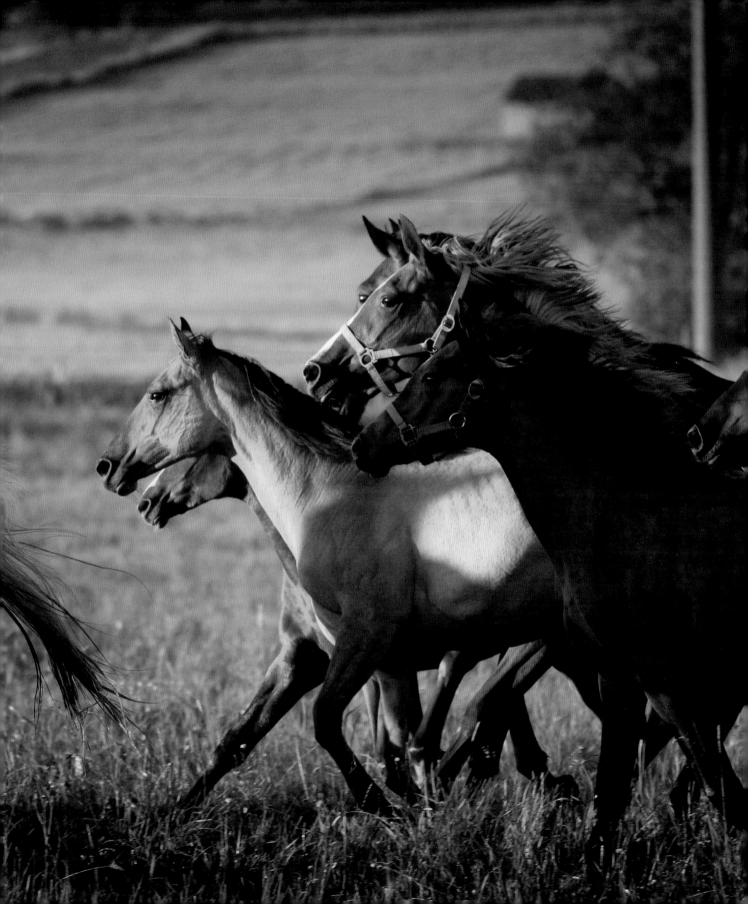

THANK YOU

So much of what we do we could not achieve without the assistance of others. I am not only grateful for all the help and support I have received during the years I have been working with horses, but I am very glad about having needed and found both. Wonderful moments, hours, days, weeks, months and years of being close with very special people – all this time in shared love for the horses is a reward for my work that could not be more meaningful to me.

I am indebted especially to Lars Rasche, without whose belief in my dreams and without whose commitment to my interest in equine photography, not one of the shown images would have been possible. My sincerest thanks belong to Isabelle Ann Green for her never-ending motivation. She is a deep well of inspiration for me. And I thank you, Divinitas, for having brought to me the beauty of our world.

I thank Doris and Thomas Wehner for our shared dream, our Hessian home and for Puschkin. I thank Ingrid and Martin Rey for their endless hospitality, their generosity – and for our understanding of one another, Ingrid.

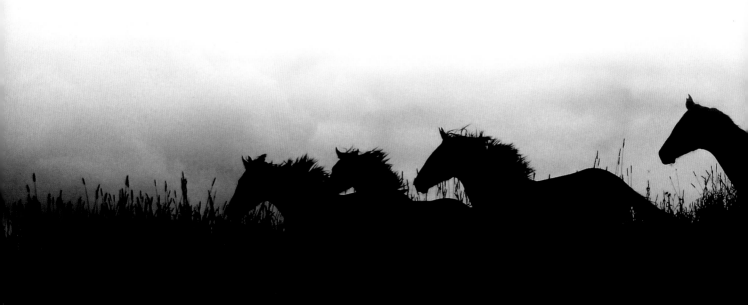

I thank Manuela Vogler, Marcus Santl, Evi Kienberger and Princess Hanusch for their great efforts, Ilse Wagner and all "our" Bavarians for wonderful days – time and time again. I thank Marion Diepenkofen and Mario Widmar for Hamit and their hospitality, and I thank Annkatrin Rabe for the wonderful conversations, our correspondence and my mind's retreat. I thank Caroline, Dörte, Marion and Andi for the Baltic baptism, and I thank Patricia and Ilona. I thank Kristin for rescuing Brandenburg. I thank Margret and Herbert Leitgen, because they have made the already beautiful even more so, and I thank Monika Seufert and all the owners of the horses shown in this book for allowing us to work with them and their wonderful horses.

Not done yet! I thank Karin and Jörg Hilpert for everything, not the least for my life. I thank our friends Angela, Anna, Michi and Ines for coming to the rescue in the times of greatest distress; I thank Sarah Koller, Gabriele Langer, Hans-Joachim Schmidtke and Anke Werner from Cadmos Publishing for what is found between these two covers. I thank the Southern Pack, the Südrudel. And I thank Andrea Behling for the right words at the right time.

Most of these great people have entered my life because of horses. It is hardly worth mentioning that my greatest thanks belong to them – those noble animals who have taught me to embrace life and to enjoy our world:

Wherever I can I will stand up for your rights, and if my pictures have shown to the readers of this book the wonder of your essence and your beauty, I hope that it will make your world a little better – for man is made as such to hold in higher esteem that which he beholds in beauty than that which he finds to be ordinary. And you have deserved our respect. You have my word on it.

STEPHEN

Imprint

Copyright © 2012 Cadmos Publishing Limited, Richmond, UK
Copyright of original edition © 2012 Cadmos Verlag GmbH,
Schwarzenbek, Germany

Layout and design: Stephen Rasche-Hilpert
Setting: Anke Werner
Cover photo: Stephen Rasche-Hilpert
Content photos: Stephen Rasche-Hilpert

Editorial of the original edition: Sarah Koller
Editorial of this edition: Isabelle Ann Green, Vermont, USA

Printed by: Westermann Druck, Zwickau

British Library Cataloguing in Publication Data
A catalogue record of this book is available from the
British Library

Printed in Germany

ISBN 978-0-85788-008-6